IMAGES
of America

DETROIT'S MOUNT OLIVET CEMETERY

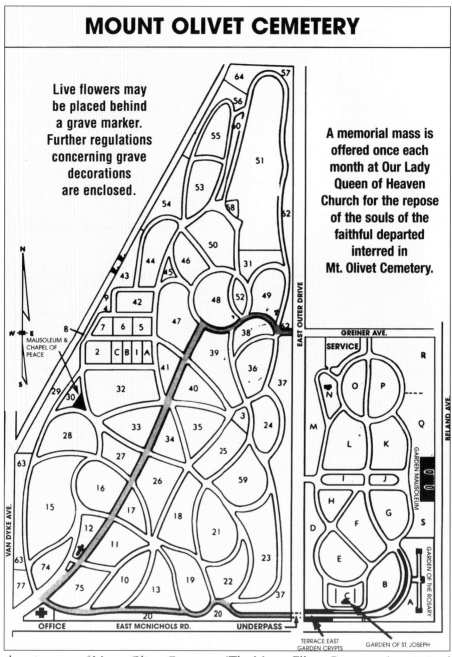

MOUNT OLIVET CEMETERY

Live flowers may be placed behind a grave marker. Further regulations concerning grave decorations are enclosed.

A memorial mass is offered once each month at Our Lady Queen of Heaven Church for the repose of the souls of the faithful departed interred in Mt. Olivet Cemetery.

Seen here is a map of Mount Olivet Cemetery. (The Mount Elliott Cemetery Association.)

On the cover: The crucifixion statue once stood outside the gates of Mount Olivet Cemetery at the corner of McNichols Road and Van Dyke Avenue. Because of its striking detail and because it was illuminated at night, many drivers did not give the road their full attention and a great number of car accidents resulted. To protect the automobile passengers and the statue, it was moved back from the road and stands in a place of honor a few hundred feet inside the main gate of the cemetery. (The Mount Elliott Cemetery Association.)

IMAGES
of America

DETROIT'S
MOUNT OLIVET
CEMETERY

Cecile Wendt Jensen

ARCADIA
PUBLISHING

Published by Arcadia Publishing
Charleston SC, Chicago IL, Portsmouth NH, San Francisco CA

Printed in the United States of America

Library of Congress Catalog Card Number: 2006925654

For all general information contact Arcadia Publishing at:
Telephone 843-853-2070
Fax 843-853-0044
E-mail sales@arcadiapublishing.com
For customer service and orders:
Toll-Free 1-888-313-2665

Visit us on the Internet at www.arcadiapublishing.com

In honor of my ancestors Franz Wendt (1837–1980) and Paulina Stelmach Wendt (1835–1919), Anna Przytulska Ewald (1873–1908), Frank J. Wendt (1869–1942), and Agata Zdziebko Wendt (1872–1908). The unmarked Wendt graves will soon be graced with tombstones.

CONTENTS

ACKNOWLEDGMENTS

I would like to thank my husband James Jensen for his interest and help in this project. We were able to visit our ancestors' gravesites at Mount Olivet during the research process. I appreciate the welcome and hospitality of The Mount Elliott Cemetery Association (MECA), especially Russell Burns, Mark Gracely, and Kari Wood. Kari has become a colleague in the research and editing of the book and Russ passed on stories and experiences of past directors of the cemetery.

The following archives were generous in the use of images and/or information for the publication: Detroit News Collection/Walter P. Reuther Library, Wayne State University (DNC/WRL); Archives of the Felician Sisters, Presentation of the Blessed Virgin Mary Province, Livonia, Michigan (AFSLM); Italian Study Group of Troy and historian Rose Vettraino (ISGT); Daughters of Charity Archives, Mater Dei Provincialate, Evansville, Indiana (DCAEI); Genealogical Society of Flemish Americans (GSFA); Bill Nicolas, owner of Schemansky and Sons Monuments (BN); and Lawrence M. Calcaterra (LMC) of Wujek-Calcaterra Funeral Home.

Local family historians also contributed images and/or family stores for inclusion. All photos from contributors are indicated with their initials after the caption, otherwise they were taken by the author. Terry Finn (TF), Sue Kramer (SK), Valerie Warunek Koselka (VWK), William Krul (WK), Joseph Martin (JM), William E. Oliver, Sue Palmer (SP), Margaret Roets (MR), Camille Sylvain Thompson (CST), Arthur and Magdalene (Sajewicz) Wagner, Frank and Elizabeth Wendt (FEW), and Frank Zynda (FZ). I counted on my Polish Genealogical Society of Michigan (PGSM) colleagues J. William Gorski, Betty and Joe Guzak, Kenneth A. Merique, and James Tye for encouragement, suggestions, and editing. Many PGSM members offered family data, documentation, and photos that could not be included due to space limitations. I ask for their understanding. B. Lewis and G. Gillon brought the Commonwealth War Graves Commission graves to my attention. Don Harvey provided information on Civil War soldiers buried at the cemetery. I can't forget my father in law, Donald R. Murphy (DRM), and cousins L. Dino DiNatale (LDD), Mary Beth Houlihan Wheeler, and Felicia Macheske (FM), who shared family photos, stories, and interest in our ancestors.

INTRODUCTION

Mount Olivet Cemetery is the second Catholic cemetery to be developed by the Mount Elliott Cemetery Association. The organization was originally formed to manage and develop the cemetery known as Mount Elliott Cemetery, established in 1841 for the need and benefit of Detroit's Catholics.

In the early 19th century, the need for a new Catholic burial ground was evident. The individual church burial grounds in the city of Detroit were being filled more quickly then expected due to population growth and epidemics. The cemeteries that did exist did not have good management of the burials, nor uniform care of the grounds. Peter Buchanan, a former Mount Elliott Cemetery director, suggests that the idea that the French had in moving cemeteries outside of Paris proper and developing rural cemeteries like Père Lachaise was similar to the motivation here in Victorian-era Detroit. The Mount Elliott Cemetery Association wanted to develop larger cemeteries outside the city boundaries of the day that would not need to relocate when the city expanded—as it surely would continue to do.

Silas Farmer, Detroit city historiographer, wrote in the preface to the 1886 *History and Rules of Mount Elliott Cemetery* that "hundreds of families in Detroit have no evidence as to where their parents or grandparents are buried, and many who are interested in genealogical research (and ought to be) would pay large sums of money to know where their ancestors lie. The present generation should remedy this evil as far as possible, and those who follow should have such a record as can now be obtained and preserved."

Farmer goes on to state that the records the association was keeping "will often be of value as a clue to settling title to property, aid many persons who do not easily find their lots, and become an increasingly valuable historical record, as the changes of time obliterate monuments and recollections."

Mount Elliott Cemetery was first conceived of by the Irish parishioners of Holy Trinity. Their representatives joined members of the other five original Catholic parishes in Detroit to develop the new cemetery and later to form the Mount Elliott Cemetery Association. Two trustees from each parish made up the original Board of Trustees. In 1881, when the development of the new Mount Olivet Cemetery began, the trustees were Richard R. Elliott and Henry D. Barnard representing SS. Peter and Paul, Alexander E. Viger and Joseph B. Moore from St Anne, Francis Petz and Joseph Shulte from St Mary, Jeremiah Calnon and John Monaghan representing Holy Trinity, John Schulte and Anthony Petz from St. Joseph, and John Heffron and C. J. O'Flynn representing St. Patrick.

The Mount Elliott Cemetery Association was forward thinking and selected the area at what is now Six Mile Road and Van Dyke Avenue (then called Connors Creek) as the site of the

future cemetery. They had not intended to open Mount Olivet as early as 1888 but the burial spaces for poor were being filled at Mount Elliott Cemetery much sooner then anticipated. Thus, on July 6, 1888, a consecration of the first section of Mount Olivet took place.

In July 1888, the *Michigan Catholic* newspaper published the following article titled "Mount Olivet: Detroit's New Catholic Cemetery."

An interesting ceremony took place on the afternoon of last Friday at a point on the line of the Grand Trunk Railroad, six or seven miles northeast of the city of Detroit. It was the consecration of a portion of the grounds of the new Catholic cemetery of Mount Olivet.

Invitations had been issued by the Secretary of the Board of Trustees of Mount Elliott Cemetery, Mr. R.R. Elliott, to a few persons privileged to witness the ceremony and a special train was chartered to convey the company to the grounds. The Right Rev. Bishop Borgess had consented to perform the ceremony of consecration, and he, with Rev. Father Dempsey, was driven from his residence at Grosse Pointe to the grounds in the private carriage of Mr. P. Blake. Some of the other gentlemen also drove to the grounds in private carriages, but most of the members of the company went by the Grand Trunk special train. Four newspaper's reporters were present for the *Michigan Catholic*, the *Evening News*, the *Free Press* and the *Tribune*.

The ceremony of consecration began at 4 p.m. After the consecration several of the gentlemen drove through the extensive tract, and were much pleased with its natural beauty and suitableness for a really grand cemetery. The land is not only what may be called "rolling" it is a series of hills and valleys almost throughout its extent. The portion consecrated last Friday is only the six acres next to the entrance near the railroad stopping place, which is devoted to single graves and the burial of the poor. But this part, even in its present condition, gives a measure of the intentions of the Trustees in regard to the whole tract. These six acres is at present a veritable garden, thoroughly drained and planted with flowers and foliage.

Not far from the entrance is a very nice, beautifully designed wooden building, to be used as a waiting room for those who have business at the cemetery and also as offices for the officials. In the large hall of this building the Trustees received the Bishop and after the ceremony of the consecration Mr. Elliott read an address with the following remarks:

"But because it was under his [Bishop Borgess] authority that these extensive grounds were located in the direction in which they lie, that is to say, east of Woodward Avenue and in a situation, probably destined hereafter, as the last resting place of the dead of succeeding generations of the Catholics of Detroit, to be safe from the desecrating contact of progressive utility.

"It is gratifying for us, especially as Trustees, to know that in the founding of Mount Olivet Cemetery, probably destined in the future to be the finest Catholic cemetery in Christendom, the name of the Right Reverend Casper H. Borgess, whose consecrated hands have this day prepared this portion of its ground for Christian burial, has been indissolubly united to its history.

"It has not been the intention of the Trustees of Mount Elliott to open Mount Olivet Cemetery for some years to come, but the reservation in the former for burial in single graves and for the burial of the poor became exhausted sooner than anticipated, and it became necessary to provide for this class of burials in these grounds. The design, in which these sections have been laid out, is destined to make them more and more attractive for the relations of those buried therein, and time will develop the artificial appliances provided. About 1,500 feet of side track, in connection with the Grand Trunk Railway, makes it convenient for the residents of the most distant parish in the western part of the city to have their funerals brought by rail at a trifling expense compared to the large outlay annually made for carriages. This will be a comparatively new feature for funerals in Detroit, and the Trustees respectfully solicit the reverend clergy, who are here present, having charge of parishes in the city, to aid them in effecting a reform in this connection.

"It will be seen that a convenient waiting room has been built for the accommodation of the public in the connection with the building of the office for records and rooms for the topographical work incidental to the development of the grounds. The transfer of this class of burials from Mount Elliott to Mount Olivet Cemetery will be made in a manner satisfactory to the Catholic community and in strict conformity to the requirements of the charitable obligations heretofore mentioned on the part of the Trustees.

"The same rules and regulations which for nearly a quarter of a century have regulated Mount Elliott will be introduced and enforced in this cemetery - that is to say - years will necessarily elapse before the many miles of avenues, the extensive work of draining, of grading and of fencing will be partially completed.

"Ten years will probably pass before its sections will have been delineated and improved, and its lots placed at the disposal of the public. It is a vast enterprise, involving in its ultimate extent a territory nearly half as large as Belle Isle Park, and it will require for its progressive working annual outlay of $10,000 - which must be carefully managed."

At the close of Mr. Elliott's address, Mr. Vhay mysteriously retired to one of the side rooms and soon reappeared with champagne and cigars. Mr. Vhay's performance was very much admired. After a short time spent in conversation, the conductor gave the hint for all aboard, and in half an hour the company was again in the city.

It was the generally expressed opinion that Mount Olivet will be in time one of the finest cemeteries on the continent. The name was also generally approved of - Mount Olivet - being between the Crucifixion and the Resurrection it embraces both.

Detroit's population continued to grow and by 1900 visitors were reaching the cemetery via train or electric street car routes. The round trip on the Grand Trunk Railroad was 35 cents. The surge in immigration to Detroit from 1890 to 1915 is reflected in the ethnic groups buried in Mount Olivet Cemetery. Belgian, German, Italian, and Polish workers as well as their cultural, business and political leaders are buried here. Each ethnic group clustered near their own Catholic parish - Our Lady of Sorrows (Belgian), St. Joseph (German), San Francesco (Italian) and St. Albertus (Polish) - and had their own funeral directors, photographers and florists. Funeral directors that started a business in particular neighborhoods included Verheyden (Belgian), Calcaterra (Italian) and Kulwicki (Polish) who officiated at the first burial at Mount Olivet.

Each group had their own newspaper as well and three founders of ethnic newspapers are buried at Mount Olivet: Camile Cools (Gazette van Detroit), Michael Domzalski (Dziennik Polski), and Monsignor Joseph Ciarrocchi (La Voce Del Popolo).

A century has passed and the city has grown up and grown old around the cemetery. Now, local families as well as historiographer Silas Farmer have stories to tell about Detroit funeral customs, Mount Olivet Cemetery, and the loved ones they have lost.

One custom, remembered by Rose Vettraino, ISGT historian, was that her husband would always place wheat in the coffin when he attended a funeral. Wheat is a symbol of resurrection. Wheat sheaves represent the divine harvest and often represent the aged.

Families have chosen an enormous variety of ways to commemorate their dead. From simple, flat military stones honoring veterans and their service to large monuments and statues and from community mausoleums to unique private ones, families do many things to personalize their loved ones' resting places. Many times, the inscriptions express the love for the deceased and sometimes, they recount a tragedy like the bronze marker in section 55 for Wladyslawa "Lottie" Lorenc. Her story was told in the magazine "Woodward" on September 9, 1999. The marker reads in both Polish and English: "Here lies 13 year old daughter of a worker, Wladyslawa Lorenc, an unjustly accused child, died after a 'police investigation' at the Harper Hospital on the 15th day of September, 1923."

Sometimes, it takes years before a grave is marked the way the family would like, as in the case of Wanda Poblock. For her sister, Jane, it was just a hop, skip, and jump along the railroad tracks until she got to the gap in the fence that led her to section 56 at Mount Olivet Cemetery.

Not far from the fence, she would find the cement marker, #391, and sit down next to the grave of her three-year-old sister Wanda.

Wanda died August 27, 1926, after eating apples sprayed with lead. Her uncle, who owned a farm, used the compound as an insecticide spray for his apple trees. In her later years, Jane recalled the agonizing car ride to an Ann Arbor hospital. Bernard Poblock, her father, raced his car along the winding roads as Wanda suffered on the back seat. At the hospital, Wanda could not be saved.

Jane always regretted that Wanda did not have a gravestone like the other children who rested around her. To stay near her sister, Jane had carved her own initials in the bark of a nearby tree where they can still be seen today. Sixty two years later, in 1988, Jane (Sajewicz) Stema, her sisters, Geraldine Bieszke and Doris Haifleigh, and Jane's daughters, Magdalene Wagner and Carol Laurence, purchased a pink granite stone for "Our Darling-Wanda Poblock."

Many things have changed over the last 120 years but Mount Olivet Cemetery will always be the final resting place of the immigrant ancestors who came to Detroit to find a better life and participate in the growth of Metro Detroit's economy. Mount Olivet is part of a legacy of the Mount Elliott Cemetery Association. It is a solid example of twentieth century burial practices and cemetery design. Its predecessor, Mount Elliott, has only private mausoleums and a small chapel and is home to the early French, Irish, German, Belgian and Polish residents of metro Detroit. Mount Olivet has a greater share of the Polish and Italian immigrants who came to Detroit from 1880-1914. The Mount Elliott Cemetery Association provides perpetual care for Mount Olivet Cemetery and its four sister cemeteries: Mount Elliott, Resurrection, All Saints and Guardian Angel.

The newer cemeteries in the Mount Elliott Cemetery Association have features never imagined by the first trustees. Guardian Angel in Rochester has marble faced crypts and niches for burial and remains in a temperature controlled mausoleum and columbarium. It is complete with skylights, music, carpeting and upholstered seating. The Prince of Peace Crematorium, located on the grounds of Resurrection Cemetery and serving all Association cemeteries, offers an option only recently allowed by the Catholic Church.

The cemeteries span three centuries and offer Catholic customs and stability in a time of restless mobility. As it enters its third century of service, the Mount Elliott Cemetery Association will continue to be "Keepers of Family Tradition."

One

MOUNT OLIVET
CEMETERY

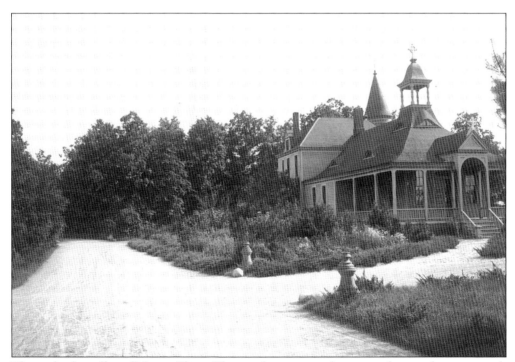

This is the first office of Mount Olivet. The wooden structure has a crucifix over the entry porch and another high atop the church-like steeple or bell tower. The building was used for waiting on families needing to make funeral arrangements as well as for all of the administrative and logistical operations necessary to maintaining a cemetery. This building was replaced by the current office building in 1914. (MECA)

This rock has become one of the symbols for the cemetery. It is one of the first landmarks a visitor sees as they drive in the gates. Said to mark the spot where the original farm house stood, the letters were affixed by the Mount Elliott Cemetery Association. (MECA)

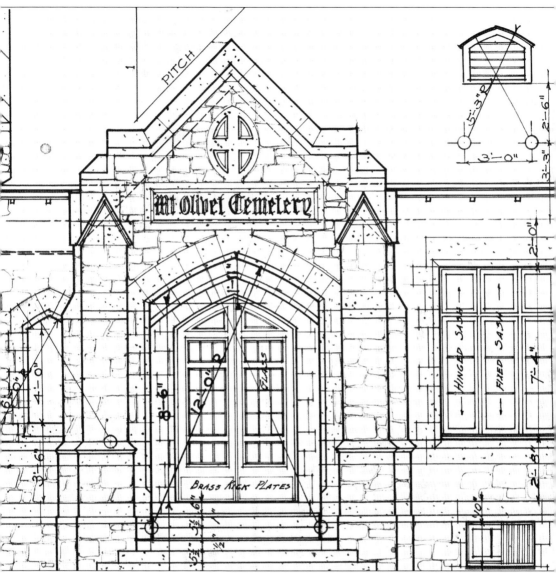

In 1914, a new stone building replaced the original sexton's house and office building. This is the doorway portion of the original blueprint by Donaldson and Meir. The building still stands just inside the main gate. After spending over 90 years as the association's headquarters, it remains the administration building for Mount Olivet Cemetery. (MECA)

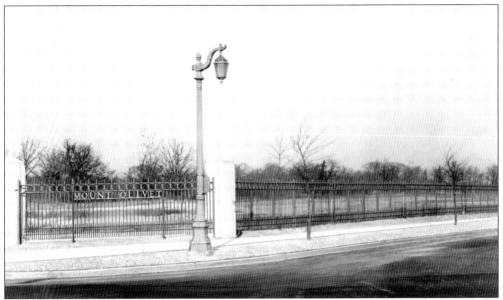

The starkness of the fence and lamppost on Van Dyke Avenue belies the community that would grow up around the cemetery. The cemetery was opened with wide dirt roads and undeveloped sections in the midst of the farmland outside the city. Today, Van Dyke is a busy thoroughfare, homes and an airport abut the fences, and every acre of space on the grounds has been developed and contains burials. (MECA)

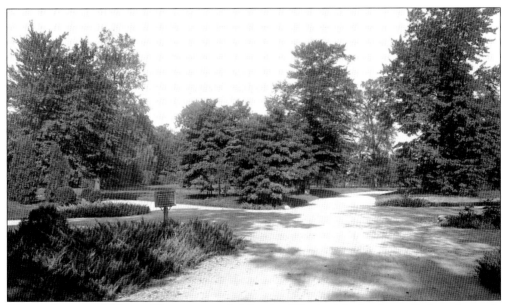

This early view of Mount Olivet is guarded by the "Don't pick the flowers" sign. An early description of the cemetery stated: "The timbered portion . . . is a striking attractive feature. The numerous varieties of native trees, shrubs and vines . . . present a fascinating picture, especially in the autumn months. The . . . improved portions embrace many rare and beautiful trees and flowering shrubs . . . and the effect produced is much admired." (MECA)

At the trolley stop, the sign reads: "Mount Olivet Cemetery/Visitors please remember that these grounds are dedicated to the internment of the dead and a strict observation of all that is proper in a place dedicated will be required of all who visit it. Persons with firearms or accompanied by dogs will not be allowed to enter the grounds." (MECA)

The rule book from 1911 states very clearly what will and will not be allowed in regard to burials, services, ownership rights, grave decorations, monuments, and visitation. What to do with one's horses is also addressed: "Visitors must not leave their horses unhitched. Should they desire to leave their carriages, they must take their horses to the places provided for hitching." (MECA)

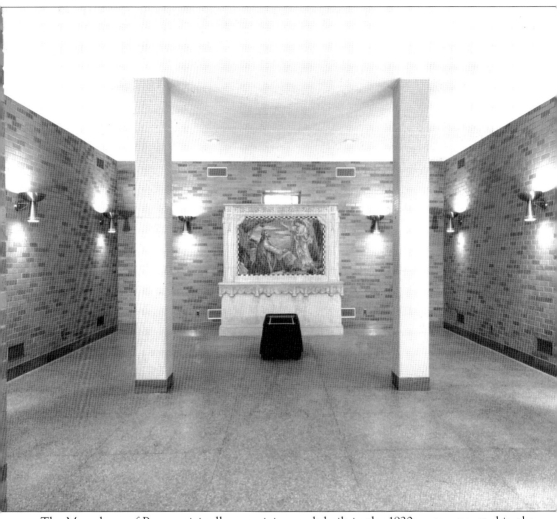

The Mausoleum of Peace, originally a receiving vault built in the 1920s, was renovated in the 1990s. The architectural style was preserved and one wing became a chapel (shown here prior to renovation), while the other was converted to crypts and niches. A new stained glass window of a cross and a dove became the logo for the Mount Elliott Cemetery Association. (MECA)

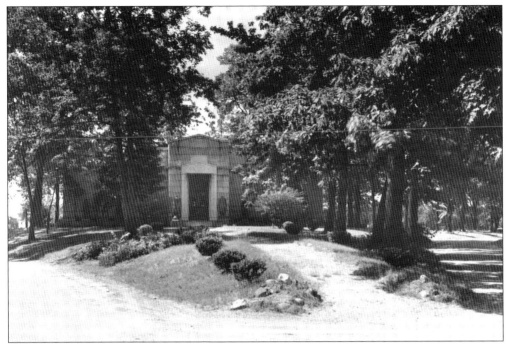

The receiving vault was situated on section 30 near the railroad tracks. This facilitated bringing remains to the cemetery located on the outskirts of Detroit. This image from the early 1900s illustrates the cemetery landscaped as a Victorian park, complete with large trees, natural plantings, and a pathway. (MECA)

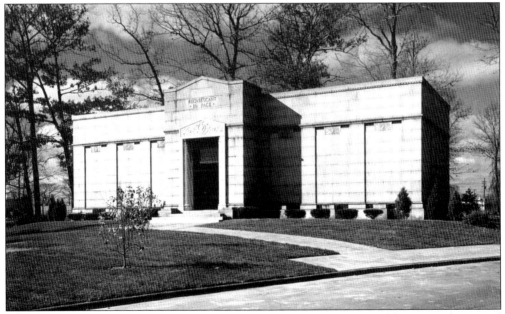

Over time, the receiving vault was less necessary due to modern machines able to open the ground during winter months. Diminished use, fashion, and the high cost of maintenance caused the cemetery landscaping to undergo changes seen here. Today, after having been renovated, the building is landscaped with flowering trees, shrubs, and plants and is much softer in appearance. (MECA)

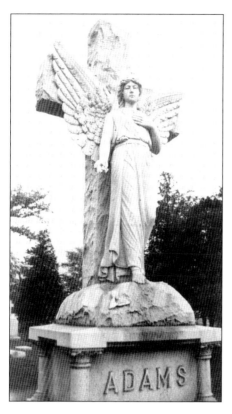

Ever present in the cemetery are angels. Angels are seen heralding, mourning, comforting and consoling. They hold wreaths, grieve with their head in their hands, and watch on in sorrow or protection. This angel watches over the graves of the Michael A. Adams family, including his wife Dorothy and daughter Isabelle. The presence of angels calls to mind the first prayer most Catholic children learn: Angel of God, my guardian dear, to whom God's love commits me here, ever this day be at my side, to light and guard, to rule and guide. (BN)

One of the first symbols of Catholic burial is the cross. There is a wide range of crosses used to mark the graves at Mount Olivet. The Greek cross looks like a plus sign, the Latin cross looks like a *T*, and the Celtic cross has a circle (nimbus) connecting the four arms. All three types are represented at Mount Olivet in many variations. (BN)

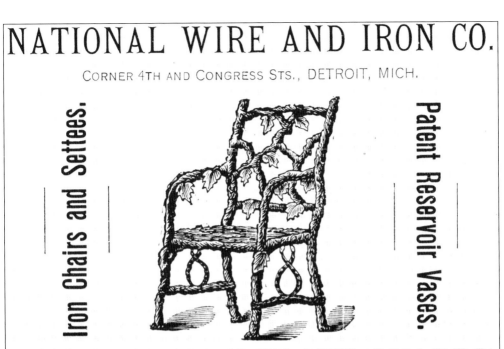

The ad for National Wire and Iron offered iron chairs and settees which could be placed in Mount Olivet Cemetery. Their line of reservoir vases were also permitted in the cemetery, but the rule book advocated hardy flowering plants, shrubs, and various kinds of trees. While ivy and myrtle were not prohibited, green sod was suggested as the neatest and most natural covering. (MECA)

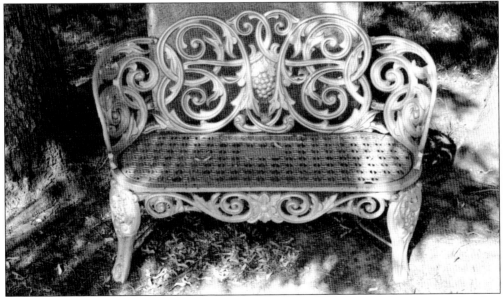

This wrought iron bench is a vestige of the garden art that once adorned the cemetery. Benches were allowed, but had to be kept in good repair and painted or they would be removed. The early rules advised that families could not follow the fashion of fencing in the lot with wrought iron. It also banned the custom of bordering the lot with either wooden or wire fencing.

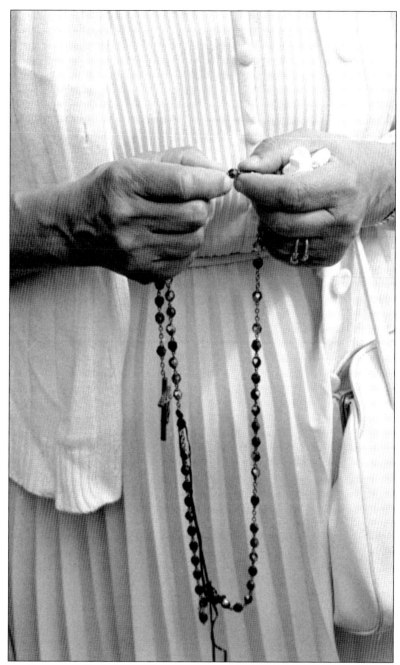

One can usually spot a Catholic in the newspaper obituaries. A phrase such as this will be included: The rosary will be recited at 7:30 p.m. Saying the rosary at the funeral home and for the dead is a Catholic tradition. The rosary itself is used to keep track of the order and number of prayers and the beads can be made from a range of materials including crystal, glass, or wood. The prayers include the Our Father, Apostle's Creed, and Hail Mary. The funeral rites for the Catholic Church were revised in 1969. The Rite of Funerals states that the first time the community gathers for prayer is usually the night before the funeral mass at a vigil and suggests a celebration of God's word such as a rosary service. (DNC/WRL)

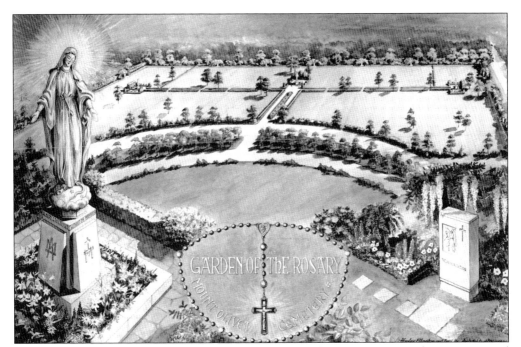

An artist's rendering of the Garden of the Rosary located in section A. In this section stand monuments to the decades of the rosary. The Garden of the Rosary is based on the Joyful, Sorrowful, and Glorious Mysteries. It is not known if groups have ever prayed the rosary here together, but it is a peaceful place for walking the mysteries of the rosary as it is being prayed. (MECA)

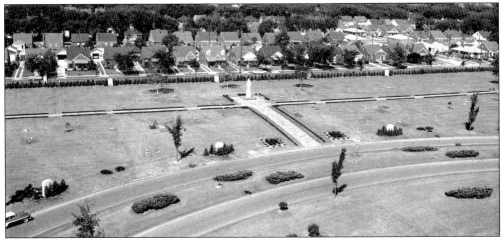

A photograph from the 1950s shows the newly opened Garden of the Rosary in section A. (MECA)

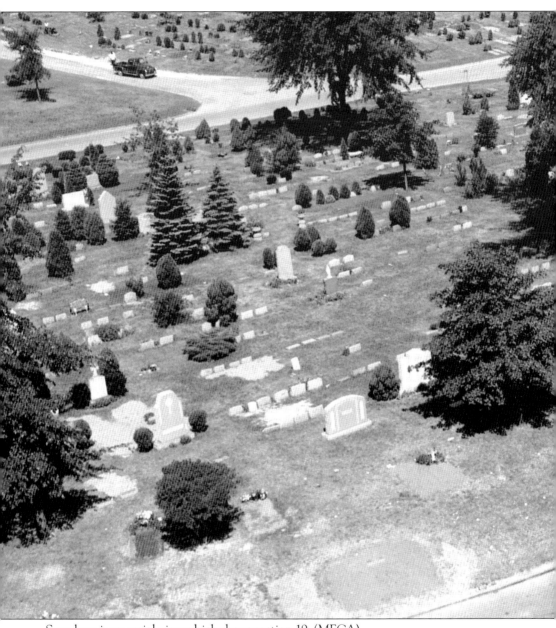

Seen here is an aerial view which shows section 19. (MECA)

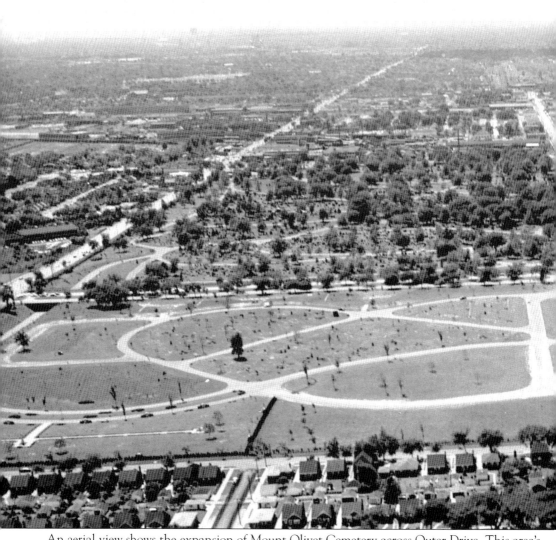

An aerial view shows the expansion of Mount Olivet Cemetery across Outer Drive. This area's sections are labeled with letters instead of numbers and contain the two community mausoleums

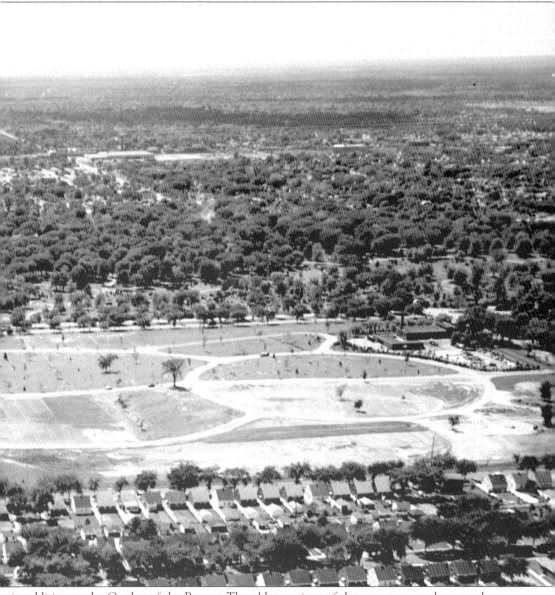

in addition to the Garden of the Rosary. The older sections of the cemetery can be seen above the newer sections, but many of the roads are obscured by mature trees. (MECA)

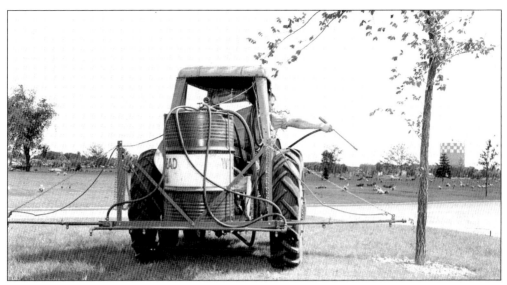

With hundreds of acres and thousands of trees to care for, every new development in technology has made work easier for the dozens of men that tend to the grounds of the cemetery. (MECA)

The main gate and fencing of Mount Olivet at Van Dyke Avenue and McNichols Road is constructed of stone and iron. The right gate pillar contains a dedication stone to Alexander Lempke, a former trustee of the association. (MECA)

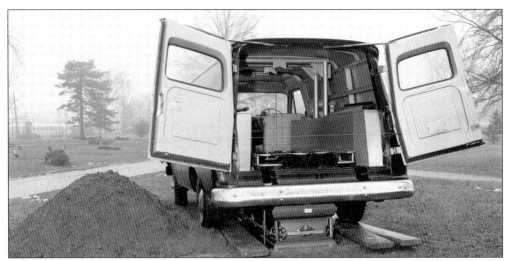

A converted, custom Chevrolet Suburban allowed for making the 5,000 burials a year in the 1960s at Mount Olivet Cemetery safer and more efficient. (MECA)

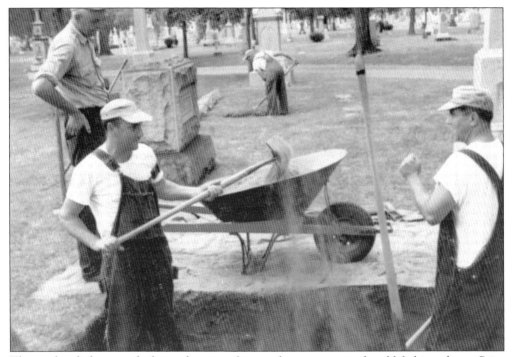

This undated photograph shows the grounds crew digging a grave the old-fashioned way. Prior to the 1960s, all graves were dug by hand, taking two men an average of six hours to complete. In a *Detroit Free Press* interview, Larry Van Overbeke, former superintendent who retired in 1996 after 43 years, mentioned that when he started, the cemetery conducted 24 funerals a day with 76 employees. (MECA)

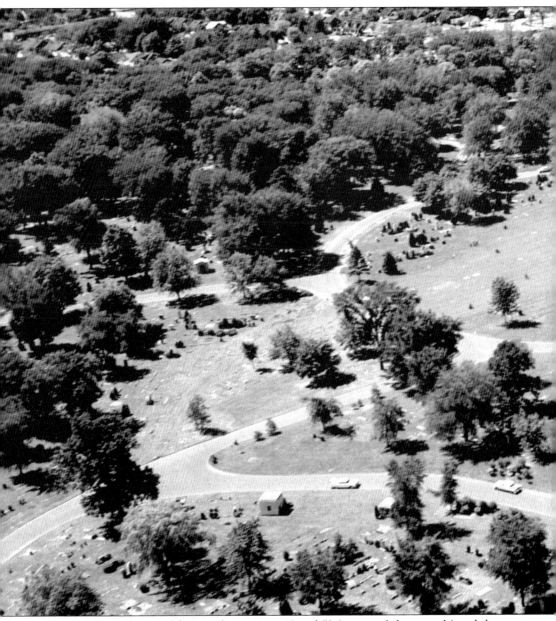

Here is an aerial view of the circular sections 48 and 52 (center of photograph) and the sections

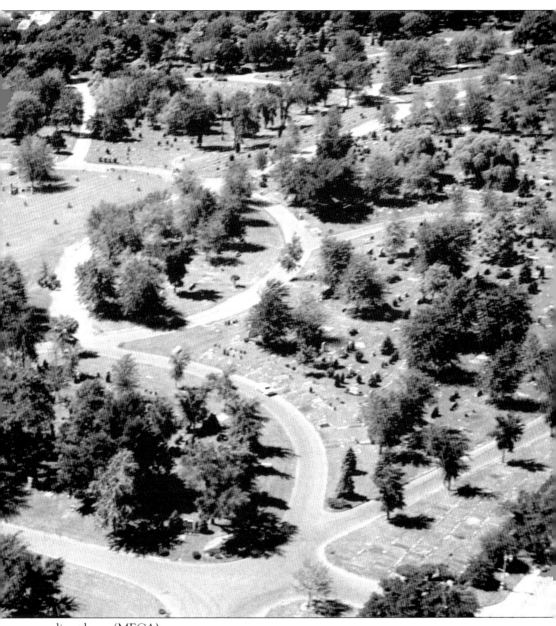

surrounding them. (MECA)

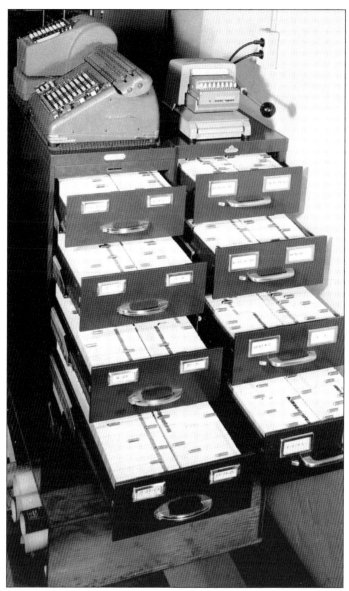

Shown are only a few of the many files recording the property owners and over 300,000 burials at Mount Olivet Cemetery. The office machines on the cabinets have been replaced by modern computers and printers, but the card files are still used everyday. The office is happy to do look-ups for researchers. Requests for multiple look ups (more than three) are best served by submitting them via mail, fax, or e-mail. There is no charge for this service and birth/death dates, funeral homes, and burial locations are able to be provided. If a researcher is seeking the place of birth, parents' names, or cause of death, they are directed to order a death certificate from the City of Detroit, Wayne County, or the State of Michigan. The U.S. Census, church burial records, and funeral homes can also reveal new information on your ancestor's life and death in Metro Detroit. Death certificates usually list birth and death information, cause of death, spouse, and some have the length of time spent in the community. An informant of the death will be listed and is often a relative. The doctor attending to the decedent and the funeral director will also be listed. (MECA)

Two

FAMILY STORIES

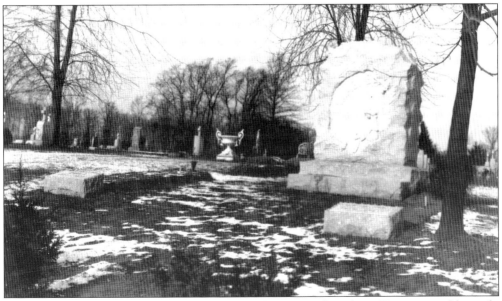

The Tamagne angel sits in quiet reflection over the graves of Anthony Tamagne and his wife, Mary. Mount Olivet is a family oriented cemetery. It is not uncommon to find several generations buried near each other. Descendents of early Detroit settlers as well as the immigrants who arrived in the late 1800s and early 1900s are found throughout the cemetery. (BN)

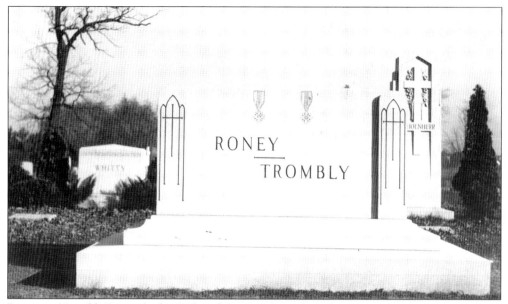

Rosemary Trombly Roney (wife of Edward C. Roney) purchased this monument and two markers for her parents, David Trombly (1840–1919) and Mary Greiner Trombly (1858–1932). It was ordered in May of 1929, and placed on the family lot in section 39. The Trombly family is an old French family and their ancestors include the Rivards. Mary's father was Michigan senator Michael Greiner. (BN)

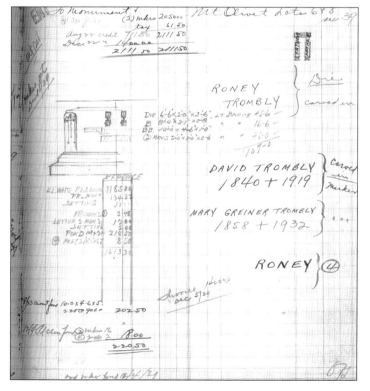

The ledger page from the records of Otto Schemansky and Sons shows the purchase and design of the Roney monument. In 1929, the cost to produce this memorial out of Barre Grey granite was $2,111.50. (BN)

This stately Rivard monument is surrounded by several generations and branches of the Rivard family. The angel guards these early pioneers. They were farmers and lived near each other on French Road. John C. and his wife, Melissa (née Peters), are interred here with their sons, Sylvester and James, and a daughter, Rose. Also interred in this family lot are Joseph Rivard and Frances (née Baumgartner) Rivard. Nearby is the Anthony J. Rivard family and the Raymond C. Rivard family. (MECA)

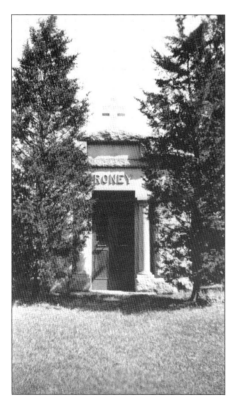

The Roney mausoleum, located in section 47, was purchased by Isabel Roney in 1916. Several generations of her family are entombed here: Edward J. Roney (died 1916), Clementine Singelyn (died 1926), Isabel Singelyn Roney (died 1937), Anne Roney (died 1945), Mary E. Roney (died 1957), Celeste Roney (died 1966), Anne Roney (died 1967), James F. Roney (died 1967), Charles J. Roney (died 1976), John J. Roney (died 1967), Isabel C. Roney (died 1989), and Catherine C. Roney (died 1990). (BN)

Don Murphy has fond memories of his grandfather Thomas E. Buckley, section 21, lot 1587C. He took Don to his first Tiger ball game in 1939. Don remembers: "He took me to Emmett Field, the old Tiger Stadium, many times. He was my father figure when I was a child. He was a good carpenter and made many home improvements to the house on Oakland Avenue in Detroit. He was a good grandfather. He took me with him to the many 'wakes' he attended. We picked up his new car (1939) at the Floyd Foren Ford dealership in Royal Oak and before we got home, I dropped my ice cream cone on the new upholstery! The only time I was ever taken to a restaurant when I was a kid, my grandfather took us. While on the Detroit Police force, he was the team captain of the baseball team. A terrific grandfather that I admired very much. Can't remember that I ever heard him use a cuss word, he loved baseball and was a true Irishman! He was my Hero." (DM)

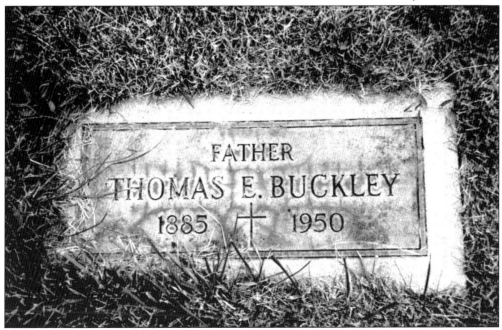

Anna Przytulski Ewald from Kuczbork, Zuromin, Poland (1873–1908) was buried with her infant son, August. In 1995, granddaughters located Anna's tombstone in section 6, tier 8, grave 936. The headstone was level with the ground and overgrown with grass. The stone had a German inscription: *Hier ruht in Gott* (Here rests in God). Marion Ritter Houlihan, Barbara Ritter, and Mary Beth Houlihan Wheeler discovered remains of gold paint in some of the incised letters and numbers.

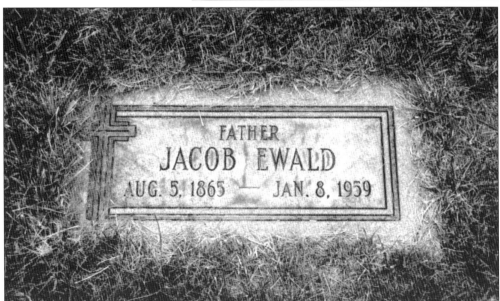

The paint confirmed the story that Marion had long recalled about her grandfather, Jacob Ewald (1865–1959), in section F, lot 496. Jacob used to walk to Mount Olivet to visit Anna's grave, carrying a little bucket of paint. His great-granddaughter Mary Beth recalls Jacob Ewald was not a man about whom many people had kind words but, as he had aged, perhaps he had mellowed and viewed this grave-tending as a reverent act to honor his long-deceased young wife.

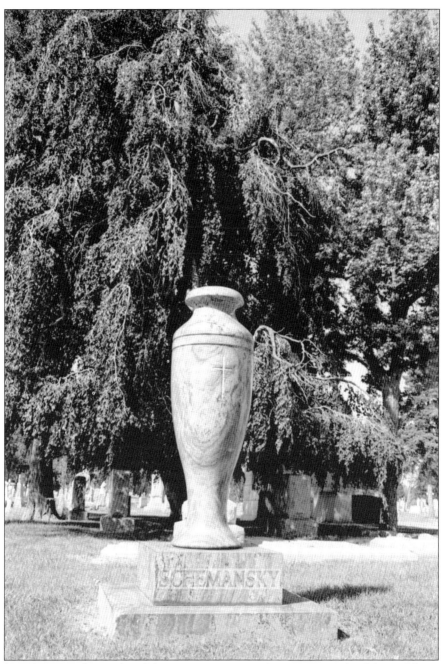

Providers of services during their lifetime, monument makers are interred at Mount Olivet. Seen here is the family lot of Otto Schemansky (1852-1912) in section 27, lot 21. The urn that graces the Schemansky plot today was on display in the showroom garden in the 1930s. Otto married Mary A. and they had seven children: Otto Jr., Elizabeth, Joseph, Carrie, Walter, Laurie, and Mammie. His business, called Otto Schemansky and Sons, produced many of the outstanding monuments and headstones at Mount Olivet. The Schemansky ledger books that still remain date back to 1906 and have the original orders, prices, and sketches for thousands of jobs. Otto Jr. married Gertrude.

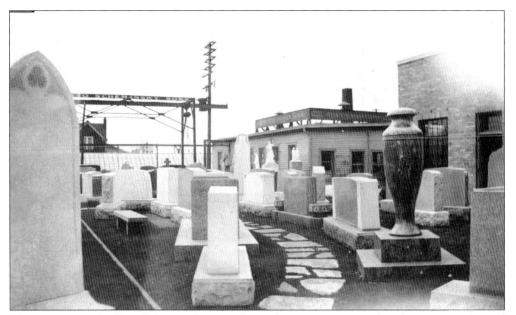

The monument for Otto Schemansky, as well as other monuments and sculptures, are pictured here in the showroom garden. Otto learned the trade during the 1870s, then joined the police force in 1880, serving two years. He reopened his monument business in 1883. Originally located on Gratiot Avenue and now located a block from the cemetery, the company is still in business and is owned by the William Nichols family. (BN)

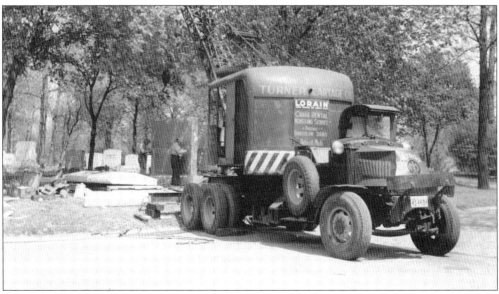

The task of setting up a monument or mausoleum called for the use of a crane. This Schemansky photograph captures the erection of a wall of a mausoleum (behind the truck). Schemansky records included a wide range of monuments and headstones. Depending on their budget and the fashion of the day, families could choose from a flat marker, a slant-face marker for one or two graves, or vertical monuments in a wide range of sizes made of marble or granite. (BN)

July 5. 1916 Mrs Megge 7/82
 654 St Aubin

To mont & marker 70000 Mt Olivet lot 46 sec 35
2 vases & settee 2500 West 12 x 12½ x 76 x 25½

TU SPOCZYWA W BOGU

JAN MEGGE

UR. 29go KWIETNIA 1864 P.

UM. 25go CZERWCA 1916 P.

PROSI o ZDROWAS MARYA

per original on file

(Vases & settee are set on lot July 29)

Jul. 20 ord. statue Italian mbl Co.
Ord. Mt. Woodbury Gr Co.

note mont erected in ...
note statue erected ...

When Mrs. Megge of 654 St. Aubin ordered this cross from Schemansky, she chose to have the inscription written in Polish. The first line is *Tu spoczywa w Bogu* (Here lies in God) Jan Megge and ends with *Prosi o Zdrowas Marya* (Asking for a Hail Mary). Jan (John) was born April 29, 1864, and died June 25, 1916. Notations on the order state a four-foot-six-inch Italian marble statue was ordered July 20th, and vases and a settee were placed at the site, section 35, lot 46. (BN)

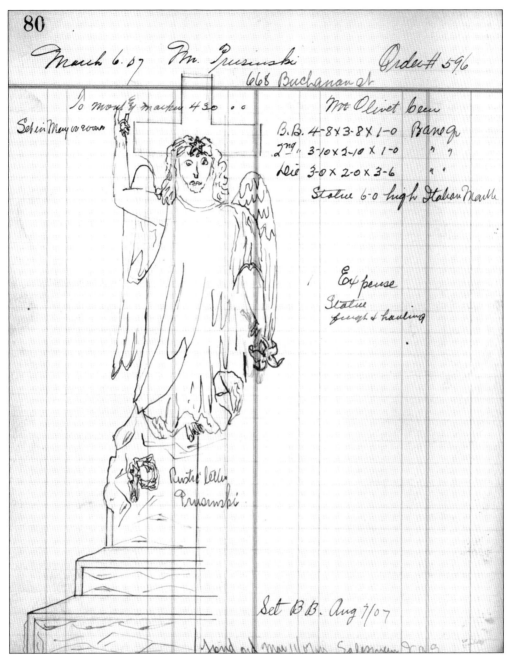

March 6.07 Mr. Prusinski Order # 596
668 Buchanan St

To mon[?] marker 430 .00

Set in May or June

Mr Olivet Cem
B.B. 4-8 x 3-8 x 1-0 Barre Gr
2nd " 3-10 x 2-10 x 1-0 " "
Die 3-0 x 2-0 x 3-6 " "
Statue 6-0 high Italian Marble

Expense
Statue
freight & hauling

Rustic letter
Prusinski

Set B.B. Aug 7/07

Joseph Prusinski and his wife, Prakseda, owned a bakery and employed their son, Clemens. Daughter Nellie, was a milliner while Helen, Anna, Sophia, and Johanna rounded out the family. This imposing monument—section 27, lots 50 and 51—is composed of a cross and angel. The cross stands over the six-foot-high Italian marble angel. The angel is pointing to heaven and holds a lily, a symbol of resurrection. Joseph ordered the family name spelled out in rustic lettering. (BN)

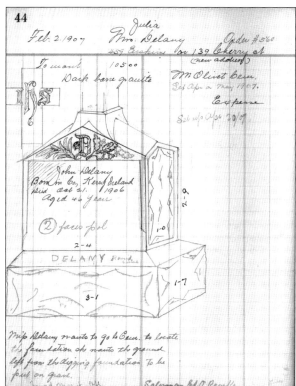

Mrs. Julia Delaney ordered this tombstone for John Delaney on February 2, 1907. The Delaney monument—section 34, lot 58—is made of Barre granite and has a Gothic *D* set off with a spray of palms (a symbol of victory over death) on the left, and oak leaves (a symbol of eternity) on the right. Julia thoughtfully left a wonderful detail of his life for future generations, that he was born in County Kerry, Ireland. (BN)

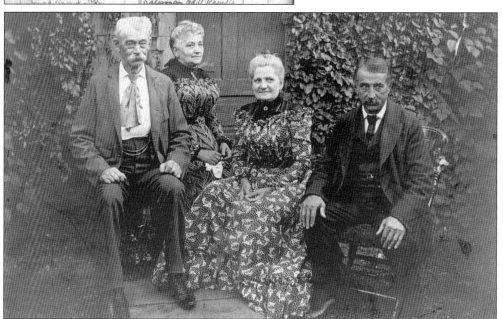

Adolphus Dewey was born November 5, 1831, in Canada. He worked for many years as a ship's carpenter at Detroit Dry Dock. In 1869, he married Emily Dongereau. They had five children: Mary in May 1870; Lucy, October 1872; Rose Maud, October 1874; Irene, November 1881; and Arthur, September 1883. Emily died January 18, 1902, and Adolphus died June 7, 1910. They are buried in section 26, lot 110. (SP)

Three

FLEMINGS IN DETROIT

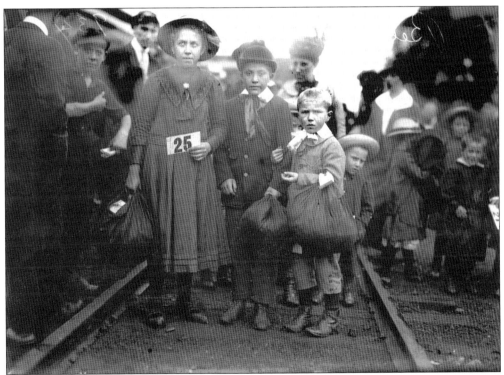

The Decoster children, from left to right, Nora (age 11), Moritz "Maurice" (age 8), and Paul (age 10), along with 105 others, arrived with Father Syoen's group of refugees from Cortemarek (Kortemark), Belgium. They arrived in New York August 6, 1915. Their arrival in Detroit from battle torn Belgium garnered them front-page coverage in *The Detroit News*. They were headed for their parents, August and Romaine Decoster in Dearborn. Other children were headed to parents and relatives in Gratiot Township, Connor's Creek, and Detroit. (WRL)

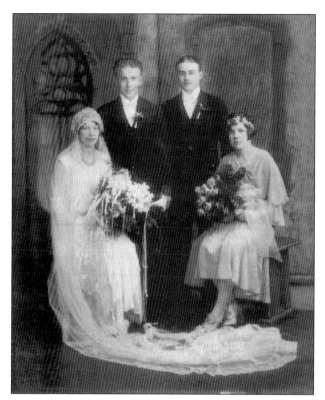

Paul Decoster (1907–1982) married Irma Declercq on May 17, 1930, at Our Lady of Sorrows Catholic Church. They are pictured here with attendants Andre Declercq and Marie Decoster Samyn. Paul attended the 1978 Flemish reunion along with Nora and Moritz "Maurice." Irma died in 1961 and Paul married Mabel Mary Verduyn in 1965 at St. Brendan Catholic Church. He is buried in section F, lot 1509.

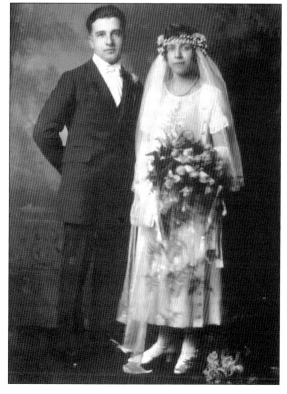

Nora Decoster (1903–1983), the oldest sibling of the trio, would later reflect on the journey. On August 23, 1978, at a Fleming reunion, they gathered as senior citizens to celebrate their trip with Fr. Henry Syoen. She had married Maurice Vandenheede (1903–1981) and was living in Grosse Pointe Woods. She is buried in section E, lot 506.

Moritz "Maurice" Decoster (1904–1985), is pictured here, on his wedding day, with bride Marie Vandenhee. He attended the Flemish reunion along with Julian Victor, Irma DeGroot, Gustave Van Ryckeghem, Angela Stafford, and Yvonne Samyn. There is a photograph of the group gathered around a portrait of Father Syoen, whom King Albert of Belgium had made a Knight of the Order of the Crown. He is buried in section I, lot 129.

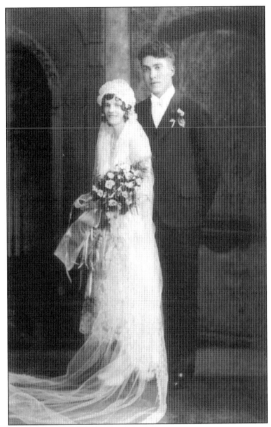

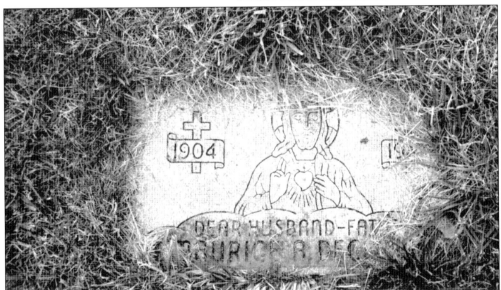

Simple in its design, Moritz "Maurice" Decoster's tombstone reads: Dear husband and father. It has an engraved image of the Sacred Heart of Jesus and a crucifix. The marker follows the current Mount Elliott Cemetery Association regulations that all individual grave markers must be of granite and set flush with the surface of the earth, and is located in section I, lot 129.

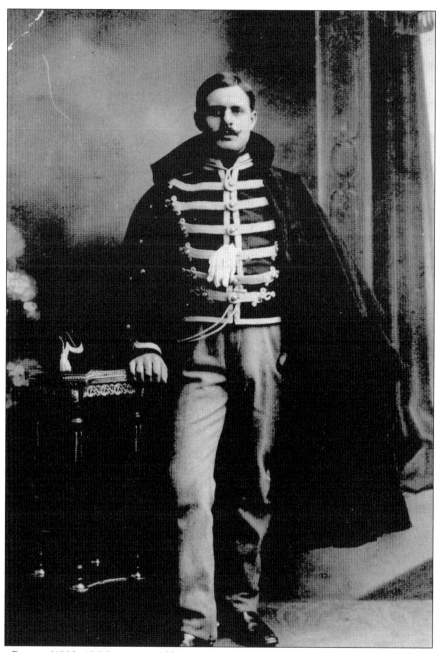

Everest Pattyn (1892–1961) is pictured here in his cavalry uniform. Since he was the eldest son, he had to spend four years in the military. When he had served three years, World War I began and he spent another four years in uniform. After the war and his marriage to Marie Vandewalle (1891–1960), the couple left for the United States. Arriving in Grosse Pointe Park, they lived in a small house at the back of the property where his sister Coralie Storme lived. This house was called an "alley house" because of the alley which separated the property from the row of lots on the next street. His children, Margaret, Edward, and Albert, were often entertained by his ability to perform gymnastic feats learned during his service in the peacetime cavalry. He is buried in section O, lot 160. (MR)

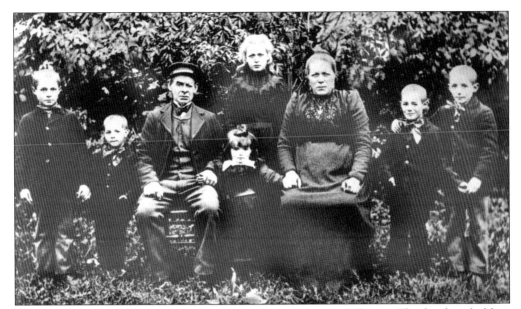

This is a charming portrait of the Pattyn family in Bekegem, Belgium. The family is holding hands, with mother Marie Louise and father Edward Bernard holding onto Sidonie, then the youngest child. The other children, from left to right, are eldest son Evarist, youngest son August, Coralie, Achiel, and Louis. Five of the individuals pictured in this photograph are interred at Mount Olivet in section O, lot 160. (MR)

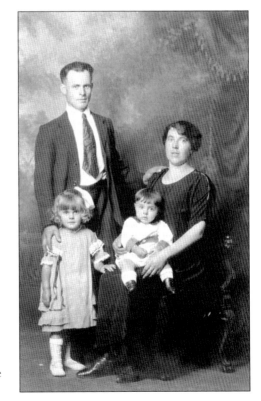

This Pattyn family portrait was taken in the 1920s and includes Evarist, his wife Marie, and children Margaret and Edward. The portrait is especially remembered by Margaret because of the dress she wore which was made by her mother. The portrait was taken at Ginsburg Studio on Mack Avenue, a popular place at the time for family portraits. (MR)

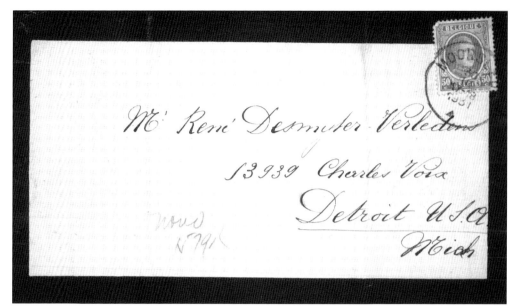

Families in Detroit kept in touch with their Belgian relatives. When a death occurred in Belgium, they would receive a death notice (*DoedBrieven*) or funeral invitation in the mail. This custom is still practiced today. Belgian women use their maiden name or birth name for all legal purposes from birth to death. Many revert to their maiden name socially when widowed. This envelope was addressed to Rene DeSmyter and his wife Martha Verledens, residing at 13939 Charlevoix, Detroit, Michigan. (SK)

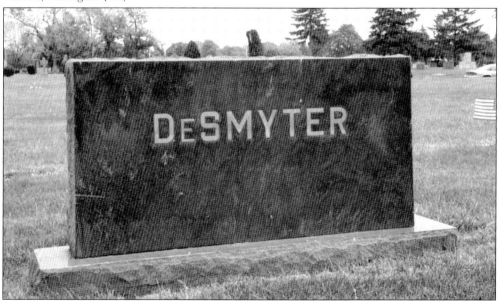

The DeSmyter monument marks the graves of Dr. George C. DeSmyter (1915–1993) and his wife Sandra (1933–1968) in section 21, lot 768. Dr. DeSmyter, son of Rene and Martha, was a graduate of Loyola Medical School in Chicago, and served as a captain in the U.S. Medical Corps during World War II. He was a family doctor known for house calls and was a member of the Belgian American Century Club. He was survived by his wife, Patricia, one daughter, four sons, and six grandchildren. (SK)

When the black edged envelope was opened there was a standard message of sympathy inside and a list of the surviving relatives and their relationship to the deceased. This letter announces the death of Martha's father, Jean-Alois Verledens, in Moorslede, Belgium, on March 30, 1931. It closes with an invitation to attend the funeral service on April 1 followed by the burial and a meeting at the residence afterward. The closing line is "Remember him in your prayers." (SK)

Vrouw Weduwe Alois VERLEDENS-VANGHELUWE ;
Heer en Vrouw Jean MADOU-VERLEDENS en kinders Gellen en John ;
Heer en Vrouw Camiel VERLEDENS-DEVODDERE en zoon Roger ;
Heer en Vrouw Rene DESMYTER-VERLEDENS en kinders Bernardine en Georges ;
Heer en Vrouw Leon BRUNEEL-VERLEDENS en kinders Jacqueline en Willy ;
Heer en Vrouw Jules WITTOUCK-VERLEDENS en kinders Simone en Henri ;
Heer Valère VERLEDENS ;
Vrouw Weduwe OSTYN-VERLEDENS ;
Heer Emiel VERLEDENS ;
De familiën VERLEDENS en VANGHELUWE,

laten Ued., met diepe droefheid doch kristene gelatenheid het pijnlijk verlies kennen dat zij komen te ondergaan door het afsterven van hunnen beminden Echtgenoot, Vader, Schoonvader, Grootvader, Broeder, Schoonbroeder, Oom en Bloedverwant,

Heer JEAN-ALOIS VERLEDENS

geboren te Rumbeke den 23 Juni 1860 en godvruchtig overleden te Moorslede, den 29 Maart 1931, versterkt door de laatste troostmiddelen onzer Moeder de H. Kerk.

De lijkdienst gevolgd van de begralenis tot dewelke gij vriendelijk wordt uitgenoodigd zal plaats hebben in de parochiale kerk van Moorslede, op WOENSDAG 1 April 1931, te 9 ure.

Vergadering ten sterfhuize Statiestraat, ten 8 3/4 ure.

WIJ BEVELEN ZIJNE ZIEL IN UWE GEBEDEN.

Moorslede, den 30 Maart 1931.

DRUKKERIJ C. VANTOMME-HENNEBERT, MOORSLEDE.

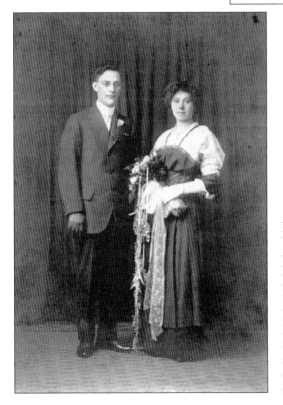

Rene DeSmyter (1892–1972) and Martha Verledens (1891–1979) are shown in their wedding portrait. Martha was born in Moorslege, Belgium. She was supposed to travel on the *Titanic*, but had to cancel because of a toothache. Martha and Rene had two children, George C. and Bernadine. The family ran an insurance and travel agency on East Warren specializing in trips to Belgium. The couple is entombed in St. Jude, level B, crypt 48. (SK)

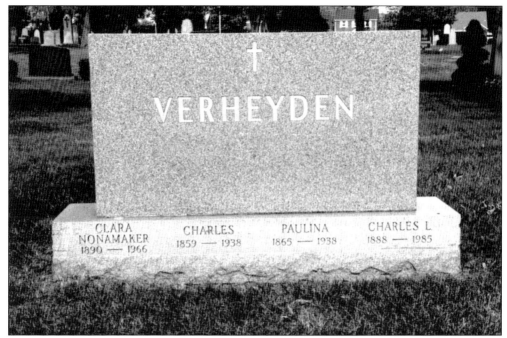

The grandparents of Charles L. Verheyden (1888–1985) left Berchem-Antwep for Detroit in the 1840s. Charles's career began with a job delivering flowers to home wakes. He developed an interest in enhancing funerals and attended embalming school in New York. Upon his return he opened his first funeral parlor in 1908. A bachelor, he was known for his love of horses and had stables in Florida. They are buried in section 52, lot 176.

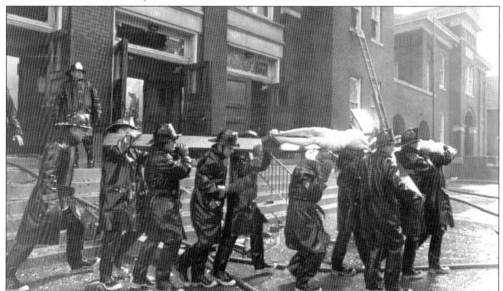

On April 10, 1963, the fire at the old Briggs Plant, located at Meldrum and Benson Streets, also destroyed Our Lady of Sorrows Catholic Church. The firemen rescued the crucifix from the church. The fire had broken out in the old factory across from the church while the congregation was attending morning mass. They escaped unharmed, but several parishioners' cars were lost to the fire. The Detroit Fire Department then had to fight both fires simultaneously. (GSFA)

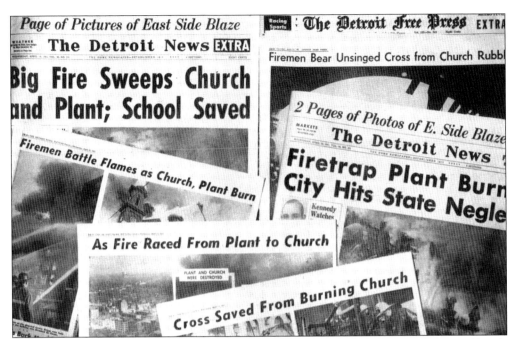

Headlines from the *Detroit News* and the *Detroit Free Press* exclaimed "Big Fire Sweeps Church and Plant," "As Fire Raced From Plant to Church," "Firemen Bear Unsigned Cross from Church Rubble," and "Cross Saved From Burning Church." The *Detroit News* had two pages of photographs of the east side blaze and the *Detroit Free Press Extra Edition* offered a page of pictures. (GSFA)

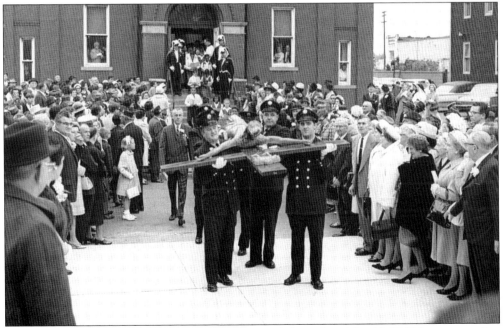

The parish raised funds for a new church and it was dedicated on May 16, 1967. It was a moving experience when the same firemen who rescued the large crucifix carried it from the rectory into the new church. Parishioners, dressed in their Sunday best, stand witness to the event. One can be seen taking her own photos of the ceremony. (GSFA)

Leon Buyse (1905–1982) was born in Inglemunster, West Flanders. He became part of the flourishing cultural and social activities in the Flemish-American community during the years between the two world wars. He wrote for the *Gazette van Detroit* and the book *Belgians in America* (1960) with Philemon Sabbe and others. His extensive collection was given to the Geneological Society of Flemish Americans, and their library is named in his honor. He is entombed in St. Augustine, level D, crypt 7. (GSFA)

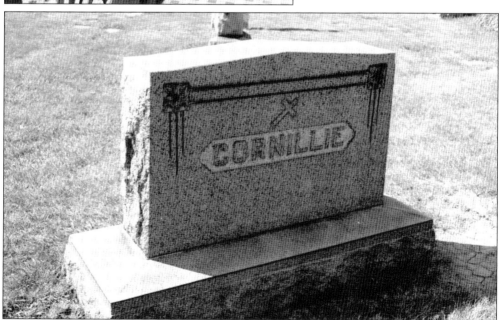

The Cornillie family heritage began with Julius C. (1879–1925) and his wife Mary Goddeeris (1884–1973). Julius immigrated from Kanegem, Belgium, in 1903. He wed Mary on June 5, 1905, at St. Charles Church in Detroit. They had 10 children. At the time of Mary's death in 1973 the newspaper stated there were 28 grandchildren and 14 great grandchildren. The family plot is in section 35, lot 113. (GSFA)

Rene DeSeranno (1910–1976) was involved in organizing and promoting projects to benefit the Belgian community and Our Lady of Sorrows Parish. He was honored for his tireless community work and was the first Flemish-American to be knighted in the "Order of t Manneke uit de Mane," in Diksmuide October 24, 1976. He was appointed honorary consul of Belgium for Michigan and is pictured here on the right. He is entombed in St. Rose, level E, crypt 8. (GSFA)

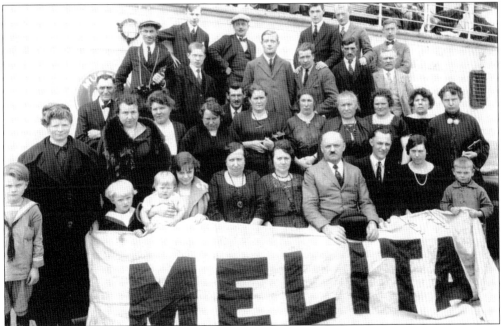

Rene and Martha DeSmyter organized trips through their travel agency to take Belgians back for visits. At first they traveled by ship but later visits were arranged via the Belgian airline Sabina. Rene and Martha are pictured here above the letter *T* of Melita. Rene (1892–1972) and Martha Verledens Desmyter (1891–1979) are entombed in St. Jude, level B, crypt 48. (SK)

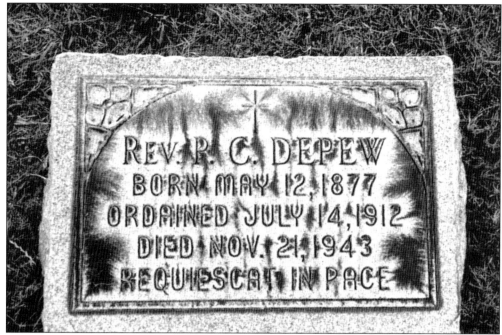

Fr. Pamphile C. DePew (DePuydt) was an assistant pastor of Our Lady of Sorrows. Pastor DePuydt (1877–1943) was selected to start the parish of St. John Berchman. He held the first mass in Jaischke's machine shop. He led the congregation to build a wooden church and in 1924 he established the church on Lakeview. He was known to hold sporting events to raise funds for the parish. He is interred in section 15, lot 1503.

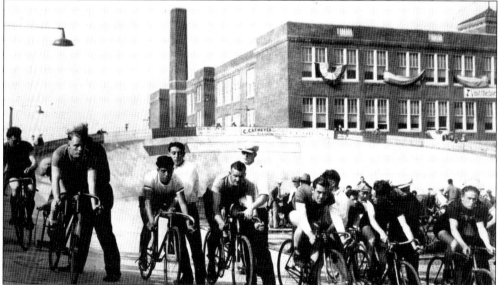

Post–World War I immigrants from Belgium brought their interest in bicycle racing. Pastor DePuydt was one of them. He and a few fans built a concrete velodrome on the church grounds. Ten laps equaled a mile. They started with amateur racing but soon had professional races as well. Races were held on Sunday afternoons and sometimes during the week. Pastor DePuydt's velodrome only lasted one year, but more velodrome and biking clubs developed.

An earlier photo of this monument in the Schemansky collection, taken in the 1930s, shows only one surname inscribed: Vandeweghe. Over the course of time, Vanhoutte and Weber were added. The Vandeweghe family came from Belgium in 1902. Joseph Vandeweghe owned a lumberyard. His and Augusta's children, Margaret and Joseph, were born in Michigan. After Joseph's death, Augusta married Achiel VanHoutte. Margaret and her husband, Lawrence Weber, are also interred here in section 15, lot 1392.

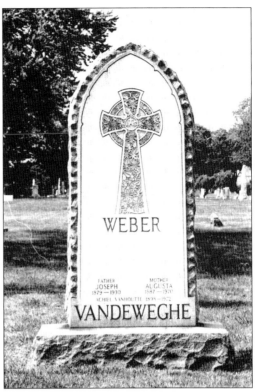

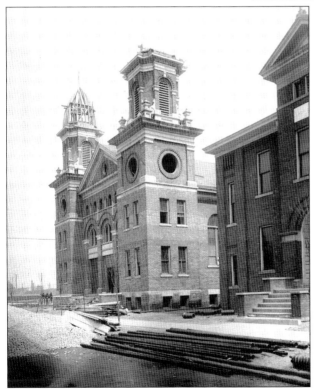

Our Lady of Sorrows Parish (1884–2000) was the first Belgian church in Detroit established in 1884 and was the heart and soul of the Belgian community. Rev. William J. A. Hendrickx was the first pastor. It was destroyed by a fire on April 10, 1963, but the parishioners rallied with the motto I shall rise again, and the new church was blessed in 1967. (DNC/WRL)

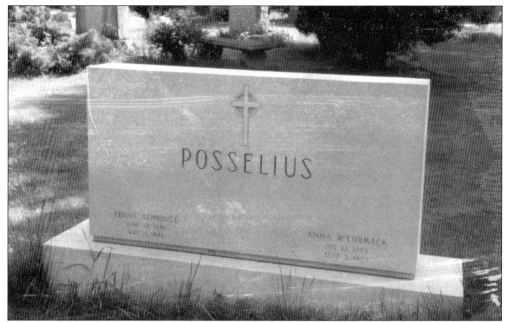

Frank A. Posselius (1886–1946) was one of Alphonse and Eugenie Posselius' three children. Alphonse arrived in the United States in 1857 from Meerhout, Antwerp, Belgium. Frank was part of the Posselius furniture business founded by his father. His grandfather founded the Posselius Brothers Furniture Factory. Frank and his wife, Anna A. (née McCormack) (1885–1953), are interred in section 28, lot 642. Alphonse and Eugenie Posselius are entombed in a sarcophagus in section 32, lot 837. (BN)

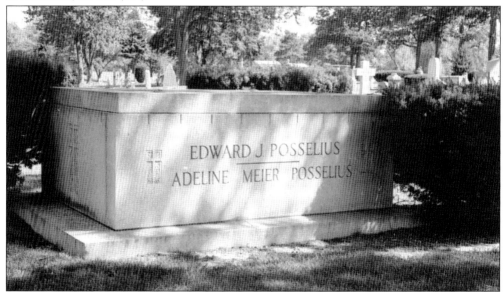

Edward J. Posselius (1888–1946) was president of the Good Housekeeping Shops of Detroit which he cofounded in 1919. He was a graduate of the University of Michigan. He and his wife, Adeline (née Meier) (1892–1973), lived in Grosse Pointe Farms. Their son Edward J. was president of the Mount Elliott Cemetery Association Board of Trustees from 1976 to 1996. Edward and Adeline are interred in section 39, lots 91 and 92.

Four

GERMAN HERITAGE

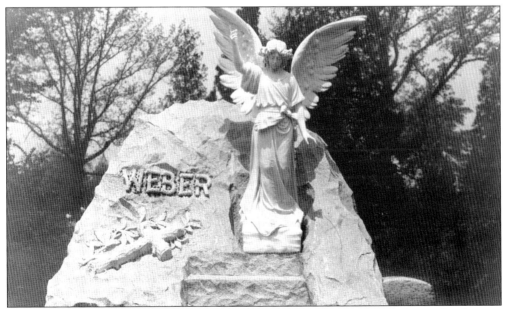

The Weber monument—section 26, lot 62—is striking. Made by the Otto Schemansky Co., it is shown in its pristine state. This angel has lost a hand from weathering, but her wings are still majestic. The headstones for the Weber family match the rustic lettering on the monument. (BN)

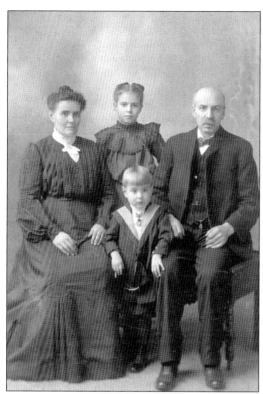

Willibald Schulte (1851–1936), son of Peter Schulte and Maria Teipel, was born October 26, 1851, in Felbecke, Westfalen, Preussen. Willibald owned Schulte and Kaiser Grocery at 983 Michigan Avenue. He is pictured here with his wife, Bertha (née Thoene) (died 1938), his daughter Mary (1895–1972), and son Francis (1903–1931). When Mary entered the postulate in 1923, she took the name Sr. M. Frances Schulte, I.H.M. With the exception of Mary, they are interred in section 34, lot 226. (SP)

Philip Christa Jr. (1865–1910) joined his brothers J. S. and Henry and his father in the family business, the Western Steam Marble Works. The sons were all born in Michigan. The family took pride in developing decorative stone work for buildings such as Russell House, Wayne Hotel, and the McGraw Street block. He and his wife, Agnes (1875–1957), are entombed in this striking sarcophagus in section 33, lot 349.

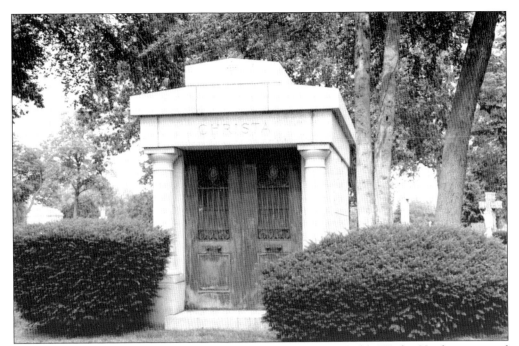

Philip Christa Sr. (1831–1910) established the Western Steam Marble Works. His firm patented marble working machinery and ran a mill that could handle stones of up to 24 tons. They imported marble and onyx from Italy, Belgium and Mexico. Philip and his wife Otillia came from Bavaria. Their mausoleum is in section 41, lot 3.

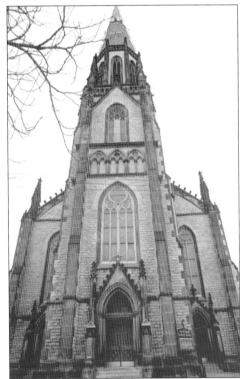

St. Joseph Parish began in 1855. St Mary's, the earlier German Catholic church, was already serving 1,800 people. Rev. Edward Franz van Campenhout left St. Mary's and was the founding pastor of St. Joseph. The church's rose window was a gift from the Friederichs family who were also parishioners. A memorial window, which features both the old and the present St. Joseph, was made by Friederichs and Staffin in honor of Father Friedland. (DNC/WRL)

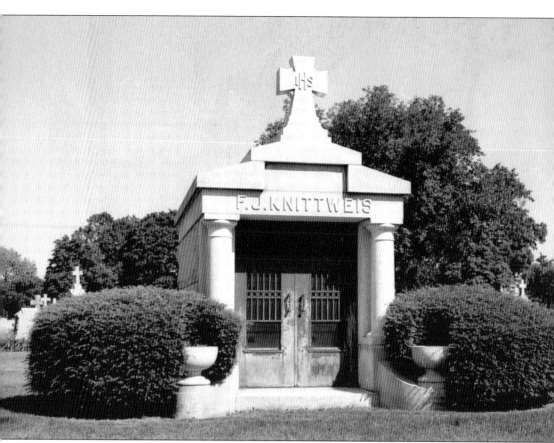

Frank J. Knittweis (1862–1928) and his wife, Anna (1863–1924), had this mausoleum built in 1922. He moved the remains of Elizabeth Knittweis and those of daughter and son-in-law George and Anna Handloser from Mount Elliott for entombment in the mausoleum. Additional burials are Anna, Francis, and Loretta Knittweis. The family had German, Belgian, and Swiss heritage, but they spoke German. The symbol used to top the mausoleum's pediment is the cross with IHS, the monogram of the name of Jesus Christ. Several more crosses can be seen on monuments to the left of the building. The classical features include Doric capitals crowning the columns and a post and lintel doorway. The metal doors have developed a beautiful patina. Frank owned a grocery business named Charles F. Funke and Company. The mausoleum is located in section 27, lot 261.

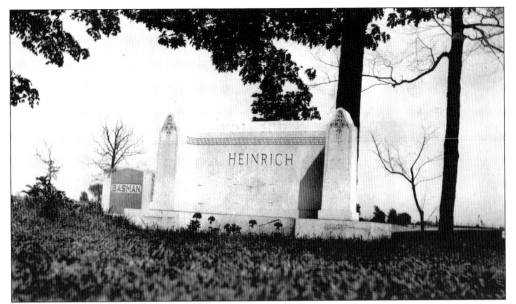

This *c.* 1930 photograph is from Bill Nichol's Schemansky monument collection. Theodore J. Heinrich's (1860–1929) monument was made out of Barre Grey granite and was ordered by his son, Edgar, who owned the Michigan Tent and Awing Company. Theodore and his wife, Elizabeth (1863–1926), were born in Germany. Son, Edgar (1886–1934), and his wife, Eva (1889–1950), are also interred in the family plot in section 21, lot 23. (BN)

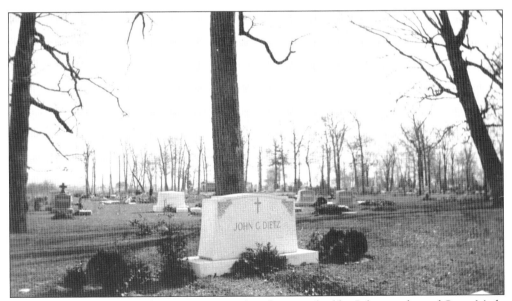

John G. Dietz's (1868–1930) monument was also photographed by Schemansky and Sons. Made out of Barre Grey granite, it was ordered by the Union-Guardian Trust Fund. John was a brass manufacturer. With his wife, Mary, he had daughters Katherine and Marion, and son, John Jr. The family lot is located in section 39, lot 90. (BN)

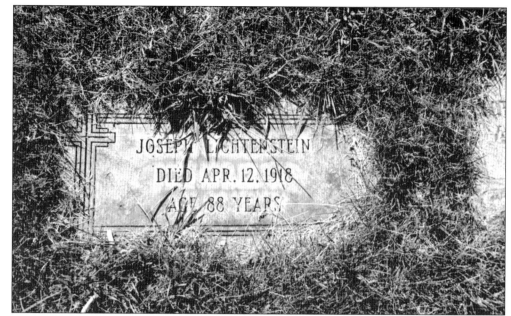

Joseph Lichtenstein (1831–1918) was called Grossvater by his Klenner grandchildren. He was a tall, thin man with a white beard and always had candy for his grandchildren. He was a leatherworker by trade and he came to the United States with his second wife, Anna (died 1900). His grandson, Fr. Hubert Klenner, was pastor at Holy Cross in Delray, Michigan, and arranged Joseph's funeral in Delray and burial at Mount Olivet in section 26, lot 17.

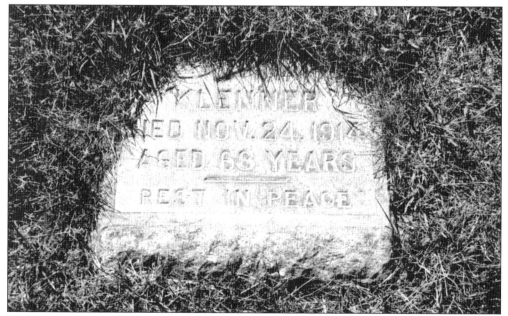

Herbert S. Klenner Sr. (1846–1914) was the son of Joseph Lichtenstein, husband of Mary Magdalen Lichtenstein and father of Rev. Hubert S. Klenner, Rudolph J. Klenner, and Mrs. Joseph A. Krausmann. He was a piano tuner by trade. An informal photograph shows him sitting at a piano with the keyboard exposed, ready to work. His funeral was at his home at 747 Garland Avenue and visitors were asked to omit flowers. He is interred in section 26, lot 17.

Frank Japes (1853–1931) emigrated from Germany in 1881. He lived next door to the Klenners on Warren Avenue with his wife, Elizabeth, and children William, Anthony, Eloise, and Leo. The family monument was ordered in 1917, after Elizabeth's death, from the Otto Schemansky Company for $800. The sketch for the monument has been preserved and shows a classic design including a carved swag on the front. It is located in section 26, lot 188. (BN)

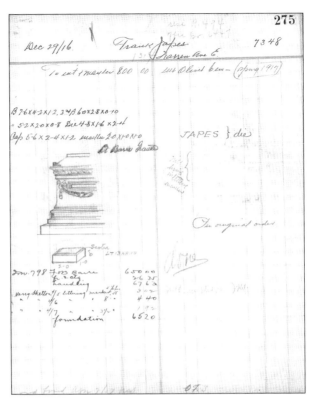

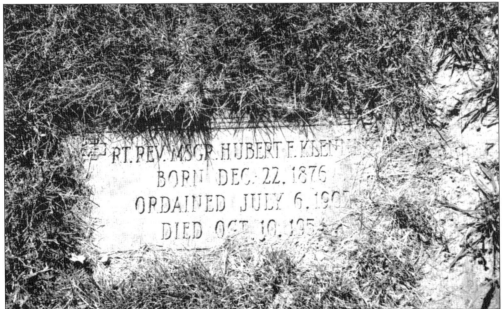

Fr. Hubert S. Klenner Jr. (1876–1954) was said to have the demeanor of a Prussian general and a voice that could quell a riot. He was ordained at SS. Peter and Paul Cathedral by Right Reverend John S. Foley in 1902. He became pastor at Holy Cross in Delray, Michigan, and later a faculty member at Sacred Heart Seminary. He remained there until his death in 1954. He is buried in section 26, lot 17.

Peter Anthony Schulte, son of Frank Schulte and Anna Mary Schneider, was born July 26, 1874, in Jackson, Michigan. When he was 14 years old he worked as a helper in a carriage manufacturer—the same occupation his father pursued while living in Prussia. Peter attended school at St. John's (Jackson) and St. Joseph's (Detroit), and then Detroit College on Jefferson Avenue. While at Detroit College he received several awards for calligraphy and good conduct. On October 20, 1897, at St. Joseph's, Peter and Rose Maud (known as Maud) Dewey were married. Peter and Maud had two children: Harriette Emily born December, 1898, and Marie Louise born November, 1900. During the 1918 flu pandemic, Peter became ill, recovered, then relapsed with pneumonia. He died on April 11, 1918, and is buried next to Maud in section 26, lot 110. (SP)

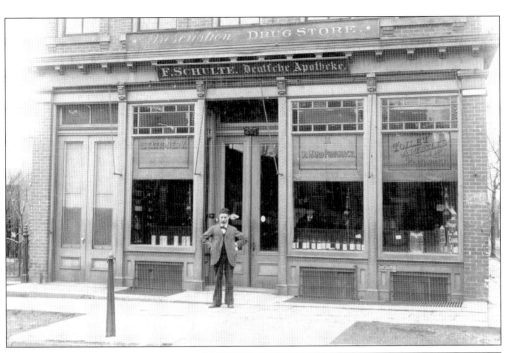

Franz (later Frank) Schulte, son of Peter Paul Schulte and Maria Theresia Teipel, was born December 7, 1844, in Felbecke, Westfalen, Preussen. Franz arrived in New York January 20, 1868, aboard the SS *Weser*. By 1870, Frank was a druggist in Detroit. He continued this profession as he moved to Jackson, Michigan, and then back to Detroit. While in Jackson, Frank was secretary for Arbeiter Verein No. 2 and recording and financial secretary for Foresters Court No. 43. In 1872, he married Anna Mary Schneider and they had three children: Peter Anthony, born July, 1874; Anna Helen, born August, 1877; and Theresa, born December, 1881. In 1890, Frank opened his own drug store, F. Schulte Deutsche Apotheke, at 255 St. Aubin Street in Detroit. Frank died October 11, 1900, and is buried next to Anna Mary in section 126, lot 110. (SP)

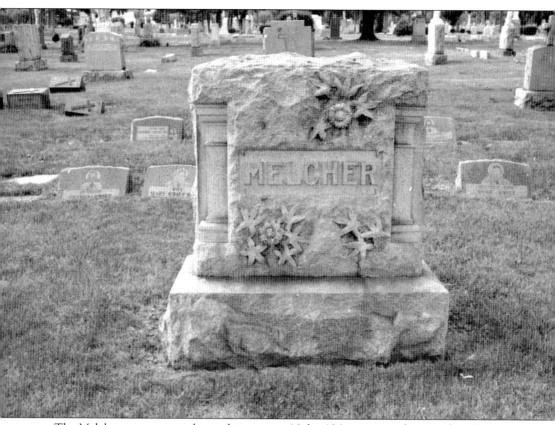

The Melcher monument—located in section 16, lot 136—is a grand piece of art. It is rusticated stone adorned with flowers and bordered by columns. The flowers appear to be lilies, a symbol of resurrection.

Five

ITALIAN FAMIGLIA

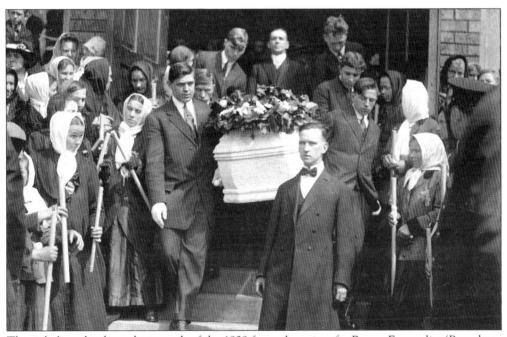

This is believed to be a photograph of the 1929 funeral services for Benny Evangelist (Benedetto Evangelista) (1886–1929), his wife Elizabeth, and four children who were murdered in their home. It remains an unsolved mystery. Several newspaper articles described the funeral and the descriptions match the scene pictured above. The first clue is "the opal-colored caskets were conveyed from the church of San Francesco, at Rivard and Brewster Streets, to Mount Olivet Cemetery on Saturday, July 6." The second clue is "the caskets were wheeled from F. J. Calcaterra, diagonally across Rivard from the church, by 16 white clad schoolmates of the eldest daughter." The third clue is "police circulated though the crowd to ensure order and detectives were on alert for hints of the slayer." The undertaker has been identified as Frank Calcaterra. Additional details in the article state that San Francesco's Rev. Francis Beccherini celebrated mass and the altar was brilliantly illuminated with electric lights and candles, and decorated with lilies of the valley. The priests wore black robes embroidered with silver, usual in masses for the dead. (DNC/WRL)

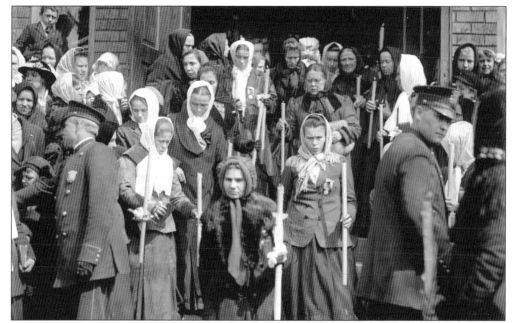

The Evangelist funeral as described by *The Detroit News*: "It was a morning of contrasts. Just across the street from the church was the undertaking establishment of Frank. J. Calcaterra where six bodies lay. The church bells rang merrily. It was summoning a wedding party. Confetti, laughter, and happy young faces on one side of the street. On the other, death. The same bell a few hours later tolled for the Evangelist family." They are interred in section 18, lot 348. (DNC/WRL)

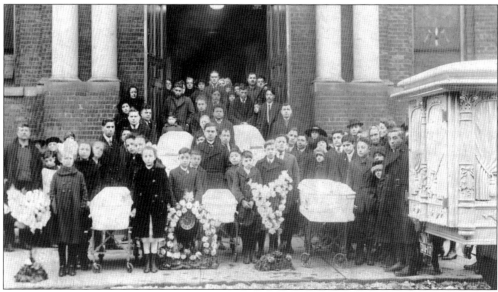

This photograph, taken in front of San Francesco Catholic Church is courtesy of Larry Calcaterra Sr. (of Wujek Calcaterra Funeral Home). It documents the funeral of the Benny Evangelist family in July 1929. The Calcaterras were the first Italian-American funeral home in Detroit and handled the arrangements. In the photograph are funeral directors Frank J. Calcaterra, Louis Calcaterra, and Paul Calcaterra. Five coffins for six people—it is assumed that the baby was buried with his mother, Santina. Note the art-carved hearse at the right of the photograph. (LMC)

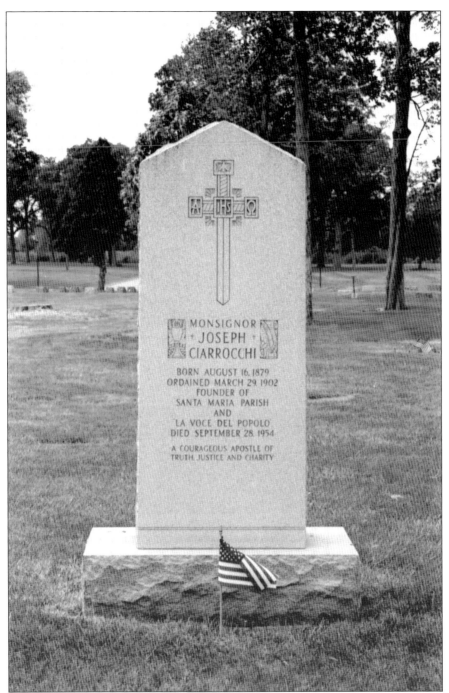

Msgr. Joseph Ciarrocchi was a religious leader as well as a political activist. He established Santa Maria Parish in August 1919. The last service there was held May 27, 1973, and then it was razed to make way for the Chrysler Freeway. Monsignor Ciarrocchi founded the paper *La Voce del Popolo* (The Voice of the People) and used it to criticize Benito Mussolini and to warn against the Italian alliance with Nazi Germany. The paper was merged with another popular Italian paper *La Tribuna* in 1970. He is buried in section 47, lot 557.

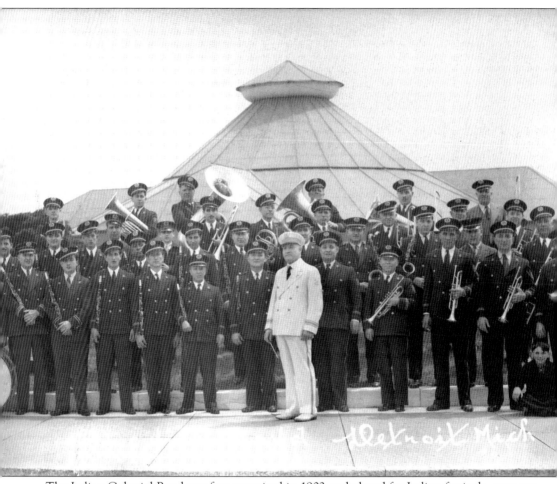

The Italian Colonial Band was first organized in 1902 and played for Italian festivals, concerts, parades, and funerals. John DiNatale and Guido Fucinari, two of band's most tenured maestros, are buried at Mount Olivet. Maestro DiNatale played in the large bands of Abruzzi, Italy, before coming to America where he found employment with Urbani's Band and later with Giuseppe Creatore's Band. He conducted the Italian Colonial Band for 20 years. Maestro Guido Fucinari was born in Detroit of immigrant parents from Frosinone, Lazio, Italy, and studied music with Peter Peralta. Maestro Fucinari studied solfeggio with hand movements and later baton. He was employed by the Detroit Concert Band, under Leonard Smith, for 31 years. He was asked to reestablish the Italian Colonial Band, of which he was a member and had played under Maestro DiNatale, to play for the closing of the Santa Maria Church before it was razed. Maestro Dinatale (1877–1966) is entombed in a sarcophagus in section 36, lot 108, and Maestro Fucinari (1921–1986) is interred in the Garden of St. Joseph, tier 8, grave 36. (LDD)

Seen here is the grave site of Frank J. Calcaterra (1890–1949), section 27, lot 169. The Frank J. Calcaterra Funeral Home was the first Italian-American established funeral home in Detroit. The first adult burial attended by the firm was that of Vincent Dimasso on August 19, 1913, at Mount Olivet in section 42, tier 14, grave 483. His first funeral home was on Rivard Street, across from Detroit's old San Francesco church. He was later joined by his brother, Louis C. Calcaterra Sr.

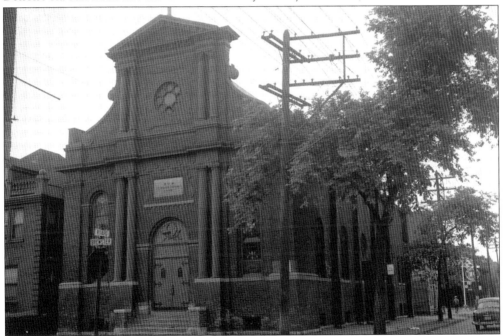

The language barrier with the Irish parishes and different social and cultural practices made the Italian parishioners long for a church of their own. In 1897, Fr. Francis Beccherini took a census and found 207 Italian families comprising 1,103 adults and 603 children. On November 20, 1898, the new church San Francesco Church was dedicated. It was located at Brewster and Rivard Streets. It was restored and redecorated after a 1944 fire. The parish was reestablished at 9800 Oakland Street in the 1960s.

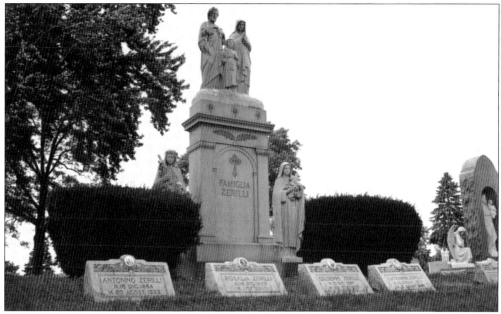

Joseph Zerilli (1897–1977) was born in Terrasini, Sicily, and came to the United States with his parents Antonio and Rosalia (Tocco) Zerilli. Ninety-eight car loads of people gathered to witnesses the lowering of his copper casket next to his parents in section 15, lot 1566. *The Detroit News* stated that his funeral was sedate compared to the one he arranged for his mother in 1932. He is said to have chartered a plane to drop rose petals along her mile long funeral cortège.

The Persichino monument—section 15, lot 1565—has been personalized with a portrait. The statue of the Blessed Mother is flanked by two kneeling angels. The head of the family was Alexander (18600–1931) who is buried next to his wife, Palma (1867–1946). They are surrounded by their family: Michael (died 1987), Angelo (died 1992), Domenico, and Francesca. Also interred here are Frances Valente, Francis Vetraino, Francine Spencer, and Luigi Delli-Colli.

This imposing monument is for Matteo (1875–1935) and Grazia (née Moceri) Licavoli (1883–1968), from Terrasina, Sicily, in section 15, lot 1546. He was a hardworking fruit merchant and they were a religious couple. The extended Licavoli family first settled in St. Louis, Missouri. When their eldest sons came to Detroit in the 1920s, they stayed in Missouri living on Bacon Street. Like many immigrant couples, the Licavolis hoped their eldest sons Peter and Thomas would become doctors or priests. The family also included son, Dominic, and several daughters.

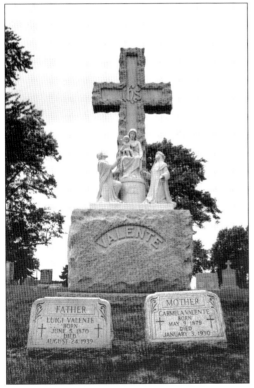

Luigi Valente was living at 3920 Rivard Street when the 1930 U.S. Census was taken. He was a widower and his immigration date is given as 1905. In his household were son Tony, daughters Phyllis and Christine, and son-in-law, John Conti. There were also grandchildren residing with him: Henry and Albert Evangelist and Marion Conti. He is buried in section 15, lot 1562.

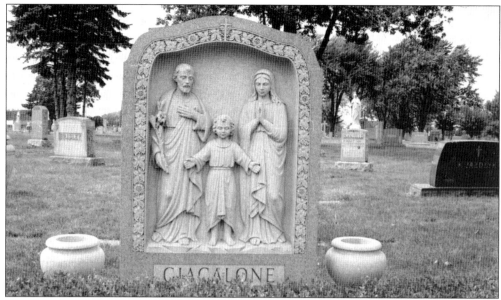

The Giacalone family—section 15, lot 1549—were parishioners at Detroit's Holy Family Church. The church was built in 1909 in a neat, Mediterranean style. The interior was filled with statues of saints. The names of the parishioners who donated the statutes—Corrado, Tocco, Giacalone, Zerilli—underscore the close ties the little church has to the Italian community.

FRANK A. CARDONI, Sculptor.

Importer and Dealer in

Marble and Granite

Monuments & Tablets

FOREIGN AND DOMESTIC.

No. 22 Gratiot Ave.,

DETROIT, MICH.

One of the original Italians in Detroit was Francesco Cardoni (1838–1904). He began a statue importing business and had a reputation as a connoisseur. The money he made he invested, but he lost his wealth during the Depression after the Civil War. In order to tide him over, he opened a monument shop. He employed Comascans from his native area of Como, Italy. He was survived by his widow, Elizabeth, and son Francesco, and created many of the monuments seen in Mount Olivet. (MECA)

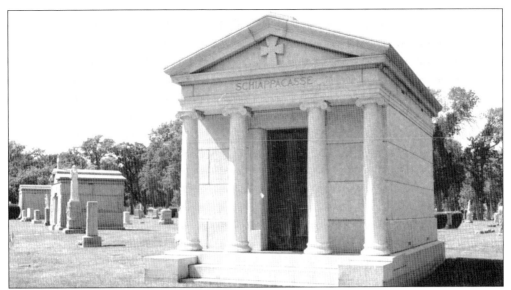

John Schiappacasse sailed from Genoa on February 2, 1865, and arrived in New York on April 4, 1865. When he arrived in Detroit he started a fruit stand on Woodward Avenue. His business was a success, and it was not long before he started a second and a third stand, until he had seven. He put Genoese immigrants in charge of his stands, furnished them, and collected the receipts. In this way, he bought larger quantities, received a better price, and had better profits. He later sold his stands and went into the wholesale fruit business knowing he would have the stand owners as customers. At the time of his death on June 29, 1916, he was one of the largest fruit wholesalers and very wealthy. He left a family of seven children including Joseph, who is a lawyer. He was the first of his family to receive a college degree and studied at Detroit College, now the University of Detroit. He is entombed in a family mausoleum in section 47, lot 144.

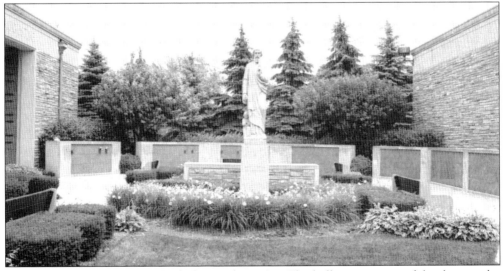

The Garden Mausoleum was built during the 1960s. The hallways are named for the apostles Peter, Paul, Matthew, Mark, Luke, and John and female saints that include Agnes, Anne, Catherine, Cecilia, Rose, and Theresa. The inscription on a crypt is limited to name and dates. Frank Sardelli (1890–1982) and his wife, Rosa (née Cappilozzi) (1895–1979), are entombed in St. Anne, level B, crypts 49 and 50.

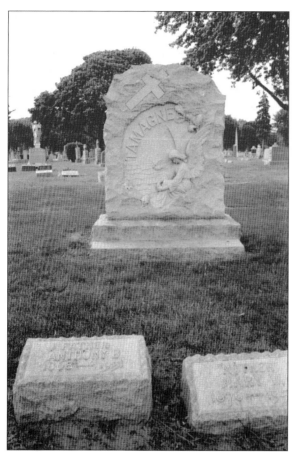

Anthony Tamagne (1868–1951) was of Swiss Italian heritage and a chef by profession. His wife, Mary, was of Irish heritage. Interred here with their parents are: Mary, William, James, Edwin, Henry, Katherine, and Anthony. Anthony Sr. arrived in the United States in 1884. Anthony was employed at a hotel and his son, William, was an apprentice chef. Katherine (1904–1924) and William (1896–1925) died within months of each other and are buried side by side. The family monument has a solitary angel who meditates near water with a shell, flower, and bird nearby and leaves overhead.

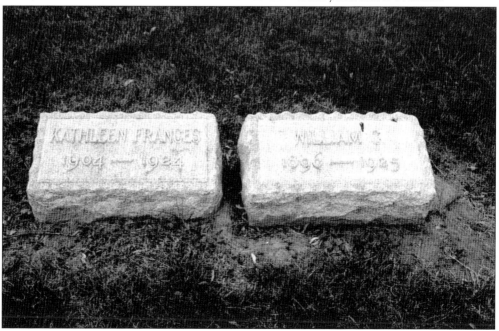

Six

POLISH RODZINA

The Victor Hebel monument—section 34, lot 208—features an angel descending the stairs with grace. Victor (1865–1939) emigrated from German Poland via Bremen and arrived at Castle Garden, New York City, on October 6, 1871. He was traveling with his parents, Michael and Henriette, and sisters Pauline and Augusta (later Nowakowski). His wife, Clara, arrived in 1882. They married about 1890. Their children were Helen, Leonard, Victor, and Clara. He was a saloon keeper in 1900 and by 1930 was a retail grocer. (BN)

The Maciejewski funeral card reads: "We have loved them during life let us not abandon them until we have conducted them, by our prayers, into the house of the Lord." This sentiment is followed by "S.P.," which stands for *Swiete j Pamieci* (saintly memory or happy memory). In English, it would be "the late" Walenty Maciejewski. Walenty (Valentine) was born on St. Valentine's Day, 1854. He died August 11, 1926. He is buried in section 47, lot 3.

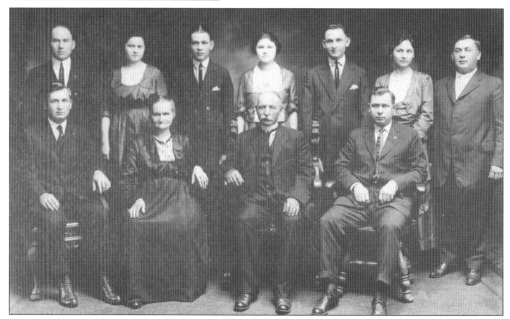

The Walenty Maciejewski (1854–1926) and Katarzyna (née Wojtkowiak) Maciejewski (1859–1938) family are captured in this portrait. The Maciejewski family was from Drzazgowo, Sroda, Posen. Katarzyna's family lived in Tulce, Sroda, Posen. They came to the United States and joined Katarzyna's brothers, Peter and Joseph. The children, in birth order, are John, Anthony, Frank, James, Peter, Sophia, Stanley, Margaret, Agnes, and Charles. (FM)

The Schemansky order book has an entry for the Maciejewski headstone for Katherine (Katarzyna). The stone was ordered by her son, Charles, who lived on Dobel. He requested a memorial to match his father's stone. Notice that he has anglicized his surname to Machesky. Other members of the family used Macheske. The headstone cost $46.35 in 1939. (BN)

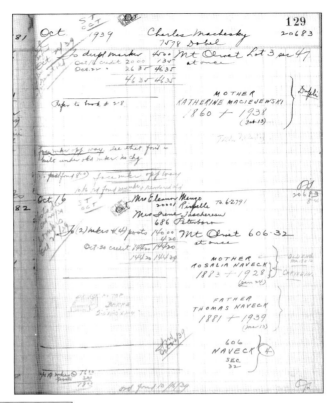

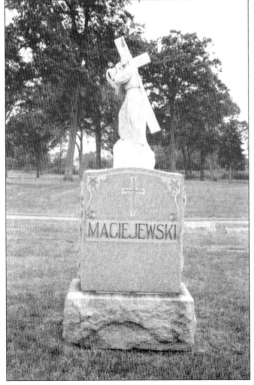

The Maciejewski monument in section 47 on lot 3 was purchased by John and Louise Machesky in 1941. Buried here are the following family members: Anna Maciejewska (died 1920), Valentine (died 1926), Baby Agnes Singer (died 1931), Katherine (died 1938), Magdalena Ostrowski (died 1941), Louise A. Machesky (died 1963), John V. Machesky (died 1976) and Catherine D. Machesky (died 1991).

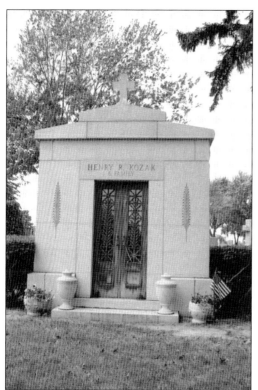

Family and friends celebrated the life of Henry Raymond Kozak (1917–2001) during an 11:00 a.m. funeral mass at Our Lady Queen of Apostles Catholic Church in Hamtramck. The founder of Kozak Distributors, a beer and wine wholesaler, died of cancer August 23, 2001, at Bon Secours Hospital in Grosse Pointe. The obituary was published in *The Detroit News*, and stated: "He was a wonderful husband, father, and a great partner," says his wife, Genevieve. Daughter Marcella McGuigan of Chesterfield, Virginia, said, "He instilled in me a strong work ethic." He is entombed in section 48, lot 453.

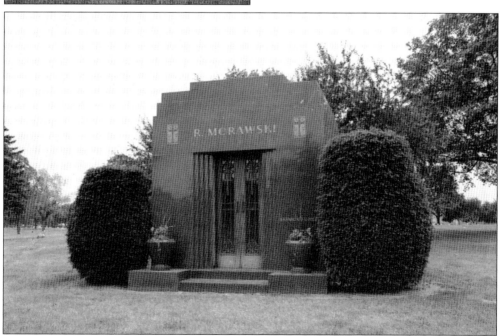

The Morawski mausoleum—section E, lot 77—is the final resting place of Raymond Morawski (1890–1957), Chester Morawski (1913–1999), Lottie Morawski (1917–1992), and also family members Edward and Leona Prina, Helen Frankiewicz, Bernard (1914–1997) and Valentina Pierce (Piskorowski) (1921–1986).

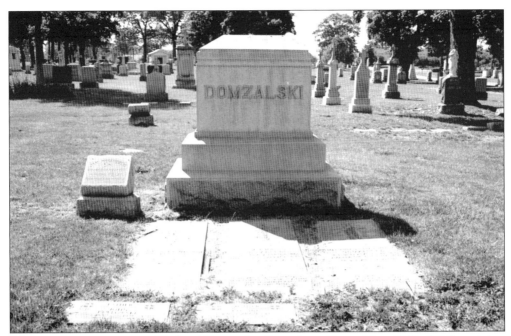

This monument—section 27, lot 123—is for Stanislawa Domzalska (1893–1934) and her parents, Michal Domzalski (1860–1939) and Marjanna Pieganowska (1862–1910). Michal was the founder of the first Polish insurance agency in Detroit and cofounder of the *Dziennik Polski* (Polish daily news).

This marker represents the merger of two Polish families, Dysarz and Zoltowski. It marks the final resting place of Anna (née Zoltowski) (1874–1960) and Charles Dysarz (1872–1952) and her parents, Walter Zoltowski (1847–1911) and Wiktorya Zoltowska (1845–1891) in section 33, lot 5. The monument depicts Christ's suffering and is enhanced by the detailed draping of this clothing and the small pine tree in the background.

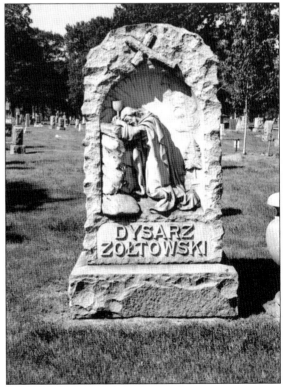

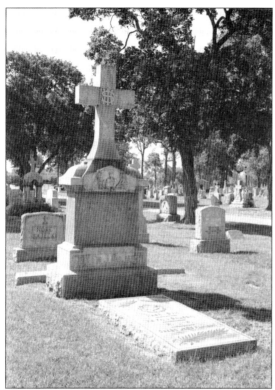

This marker is for Rev. Franciszek J. Sajecki (1873–1906) who was the assistant pastor to Reverend Mueller at St. Albertus. Reverend Sajecki discussed the idea for a new church with prominent members of the church societies and is believed to be the author of a September 25, 1905, letter proposing the founding of St. Hyacinth Roman Catholic Church to Bishop Foley. He shares this location in section 27, lot 175, with his parents, John (1845–1919) and Marcyanna (1837–1909).

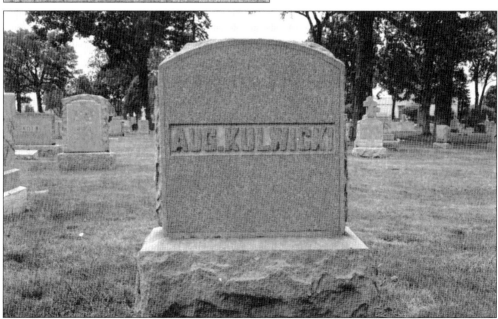

August Kulwicki Sr. was a brother of Martin Kulwicki. He was also a *pogrzebowy* (undertaker). Many Detroiters will find his name on their ancestors' death certificates. August (1854–1916) is interred in section 33, lot 147, with his first wife, Catherine Urbanowski (1860–1906) and his second wife, Anna Grunalt (died 1916), along with children Joseph H. (1888–1956) and Rose (1889–1911).

This is a unique two-sided monument in section 47, lot 534. John and Josephine Kulwicki (née Plocki) are remembered on one side, and the Plocki family on the other. The families were united by the marriage of Josephine Plocki and John Kulwicki. John's World War I draft registration described him as a married man, short, medium build with gray eyes and brown hair. He was employed at Ford Motor Company in Highland Park. John (1884–1918) is buried with son, Edward (1918–1921). The Plocki side memorializes Josephine's parents, Martin Plocki (1864–1946) and Mary (1858–1929).

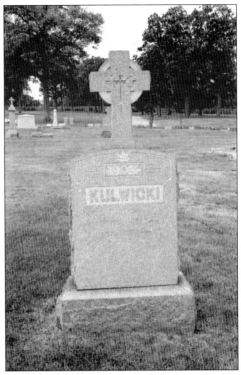

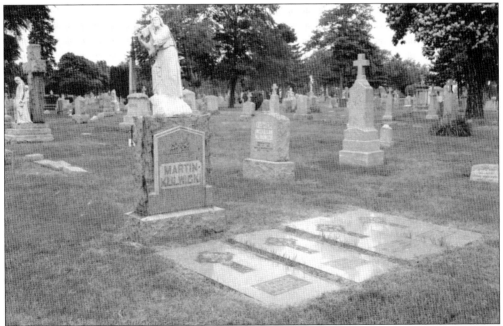

This is the marker for pioneer Polish funeral director Martin Kulwicki. He officiated at the July 2, 1888, burial of John Gruja—the first burial at Mount Olivet Cemetery. Interred in his family lot in section 27, lot 178, are the following: Martin (1858–1936), his wife Anastasia (1865–1942), and children Elizabeth Urban (1888–1970), Praxeda Bingel (1893–1918), Joseph M. (1897–1985), Mary Banaszak (1899–1940), Anastasia S. Spratke (1901–1975), and Helen Stepanick (died 1932).

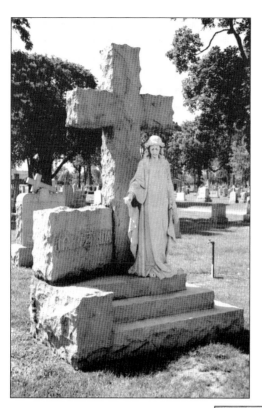

The grave of John Zynda (1858–1927) and his wives, Augusta Eichler and Ann Sanger, is marked with a large rough hewn cross in section 27, lot 129. Zynda's wealth allowed him to build a grand home at 4665 Bellevue Avenue. In his will, he demonstrated his generosity to his family and communities in Detroit and Poland. He left bequests not only to his family here and abroad, but also to the Felician sisters and Polish in Detroit and the Polish sisters of Koscierzyna for their hospital.

The monument for John Zynda, founder of the White Eagle Brewery, was created by the Otto Schemansky Monument Company. The record book sketch of the monument shows the dimensions of the cross, the stairs and the block that displays the patriarch's name. The statue of the angel must have been added at a later date. The order, dated January 27, 1908, was priced at $600. He is buried in section 27, lot 129. (BN)

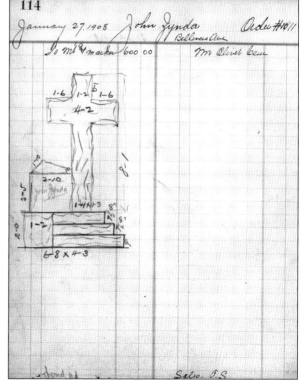

This photograph of John Zynda portrays the businessman at the height of his success. He learned his trade as a brewmaster in Koscierzyna, Berent, West Prussia. He brought this talent with him and established the White Eagle brewery in 1890. He was widely known and influential in Detroit's Polish community. When he died in 1927, the funeral was handled by Martin Kulwicki and cost $3,921. He is interred in section 27, lot 129. (FZ)

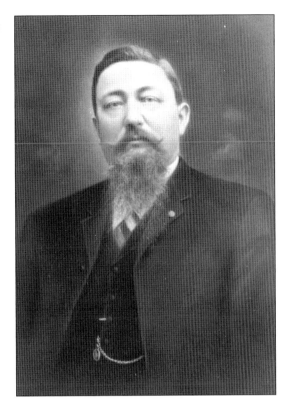

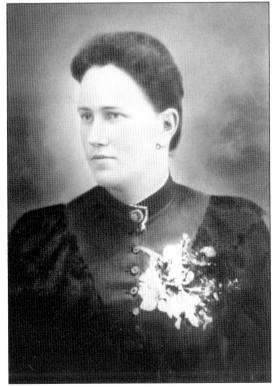

Augusta Eichler wed John Zynda in 1882. They had 10 children. The Zyndas celebrated their 25th wedding anniversary and received a set of silverware from friends. This silverware was mentioned in John's will and was divided equally among their children. At the time of John's death in 1927, eight children survived: Anna Grochalski, Rose Goike, Paulina Wessler, Helen Redlin, John, Joseph, Charles, and Leo Zynda. John and Augusta are interred in section 27, lot 129. (FZ)

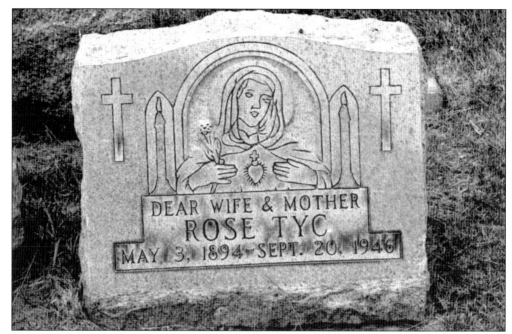

Rose Tyc (née Krajewski) was born May 11, 1894, in Parciaki (Parish of Baranowo). Her parents were Grzegorz Krajewski and Marianna Kardas. She married Jan Tyc on August 26, 1913, at St. Casimir Church in St. Louis, Missouri. She became the mother of seven children: Maryanna, Stanley, Joseph, Walter, Wladyslawa (Lola), John, and Boleslaw. She died in Detroit on September 20, 1946, and is interred in section 51, tier 82, grave 449.

Section 51 is an extensive area of 18,690 single graves. There are a variety of simple headstones and one prevalent shape is the slant-faced stone seen above.

Chester Glod was born in Braddock, Pennsylvania, on November 30, 1909, to Szczepan Glod and Rozalia Cislo. He married Stephanie Luszcz (born 1915) at Our Lady Queen of Apostles Church in Hamtramck, Michigan, on August 24, 1935. Their marriage was blessed with three sons: Eugene, Edward, and Lawrence. Chester died in West Branch, Michigan, on June 16, 1970. He is buried in section 10, lot 455.

Jan Tuchewicz (1867–1944) was born in the village of Bachotek, near Brodnica, Poland. In 1891, after his marriage to Antonina Hartka, they came to Detroit where they raised their family. The Tuchewicz family attended St. Albertus, Sweetest Heart of Mary, and St. Hyacinth parishes. After his death, his daughters took the streetcar to St. Bonaventure Monastery where Fr. Solanus Casey comforted them by saying, "Not to worry. He is already in heaven." Jan is buried in section 10, lot 543C. (VWK)

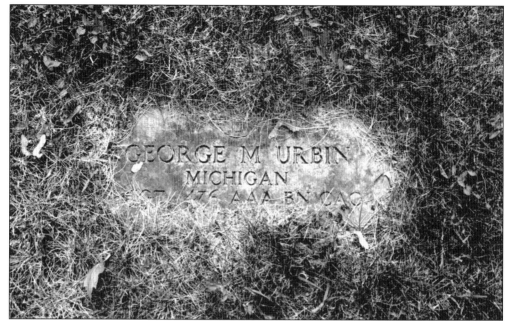

George Merique Urbin was born August 23, 1899, died October 16, 1966, and served his country valiantly during both world wars. He is the son of Louis L. Urbin (1862–1921) and Marie-Rose Merique Urbin (1858–1920), owners of the Standard Confectionery in Detroit from 1914 to 1920. He is interred in section 16, lot 64.

Walter Gustave Merique was born July 1893, and died June 26, 1977. He was the first treasurer of the City of Hamtramck from 1922 to 1932, and a Hamtramck City councilman from 1932 to 1934. His paternal grandparents, Louis Merique (1832–1905) and Marie Rose Rothenfluch Merique (1835–1921), are also interred in this cemetery. Walter is buried in section 49, lot 227.

Jacob Adamski (1857–1918) and Magdalena (née Jaskowiak) Adamski (1863–1923) were from Rogalinek, Schrimm, Posen, Preußen. They were the last of the Adamski family to immigrate to Detroit in 1907. Jacob was the coachman for Count Edward Rachinski at the Palace of Rogalin. The count described Jacob in his memoirs, *Rogalin i jego mieszkancy*. They are interred in section 32, lot 508.

Between the two world wars, Magdalena Adamska traveled back to Poland in 1923 with her son, Jacob, to visit her brother, Franciszek Jaskowiak, in Rogalin. She died on board the SS *George Washington* on the voyage back home. The ship manifest documents November 30 as the day of her death. Her remains were brought from New Jersey back to Detroit and she was interred next to her husband, Jacob, on December 12, 1923, in section 32, lot 508.

Frank Wendt's (1869–1942) grandson, Walter Banoski, has fond memories of running to the corner store at Twenty-eighth Street and Buchanan Street to buy Goike's Kashube Snuff for *Dziadziu* (grandfather). He also recalls the home wake for his grandfather at 5106 Scotten Street in 1924. There was a constant stream of city officials and attorneys that came to the house to pay their respects because Frank Jr. was an attorney for the city of Detroit. Frank is interred in section 51, tier 67, grave 634. (FEW)

Families who were not able to provide either headstones or monuments for their family members are guided by this type of marker in the ground. Pictured here are the earlier cement marker and an updated bronze marker for section 51, tier 67. Unmarked grave 634 is the final resting place for Frank Wendt (1869–1942). His second wife Mary Zdziebko Wendt (1869–1947) is buried in section 51, tier 57, grave 635.

Agata Zdziebko Wendt (1872–1908) was
born in the village of Zarzecze, Dembowiec,
Jaslo, Galicia, and came to Detroit in 1893.
She wed Frank Wendt on November 28,
1899, at St. Casimir Church. She died
in 1908, leaving five small children. Her
daughter Sophie recalled that the children
were afraid to approach the coffin because
Agata was laid out in a habit of the Third
Order of Saint Francis (*Trzeciego Zakonu
franciszkanskiego*). She is buried in section
6, tier 7, grave 893. (FEW)

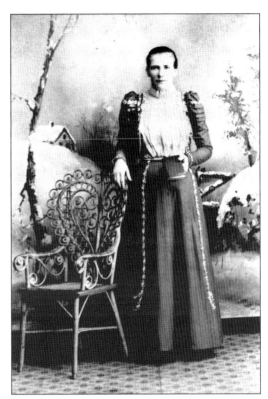

Section 6 is a section with single graves. There are some headstones, but they are flush with
the ground. This is a small section with 13 tiers. It is bordered by section 7, the burial area for
children with an area for stillborns, and section 5 which is unconsecrated ground for adults. The
Wendt family had four burials in 1908 in this area: infant Joseph Wendt (1908–1908) in section
7, tier 7, grave 581; his mother Agata Zdziebko Wendt; grandfather Frank Wendt (1837–1908)
in section 6, tier 7, grave 948; and Frank's sister Franciszka Wendt Willmowitz (1864–1908) in
section 6, tier 9, grave 39.

Three generations of the Choryan family are buried in section 15, lot 887: grandparents, Julianna (1871–1928) and August Schewe (1890–1972), parents Frances (1898–1973) and William (Boleslaw) Choryan (1890–1972), and children.

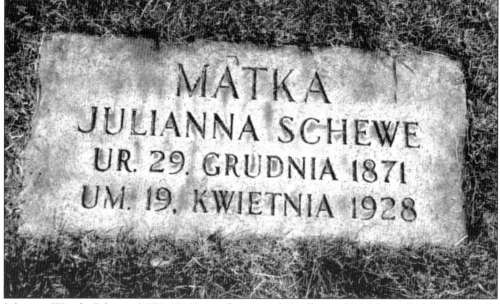

Julianna Wendt Schewe (1871–1928) was born in the village of Mahlin, Muehlbanz Parish, Westpreußen. She came to the United States with her parents, Frank and Paulina Stelmach Wendt, in 1892. She wed August J. Schewe and raised a family of seven children. She is surrounded by her husband's family and daughter Frances Choryan's family. The word *matka* means mother in Polish. Julianna's parents, Frank (1837–1908) and Paulina (1835–1919), are buried in section 6, tier 8, grave 948, and section 53, tier 3, grave 786.

Seven

RELIGIOUS ORDERS

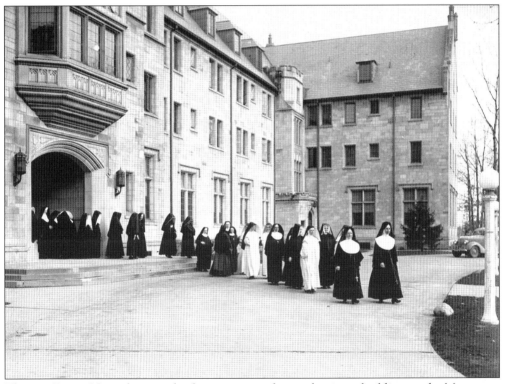

This is a *Detroit News* photograph of a procession of sisters leaving a building on the Marygrove College campus in Detroit. It was taken in 1926 and portrays the sisters in the older habits of their respective orders. After Vatican II in 1964, women's religious orders began to streamline their religious clothing for modern life. The Vatican II document *Perfectae Caritatis,* a statement about religious habits reads: "The religious habit, an outward mark of consecration to God, should be simple and modest, poor and at the same time becoming. In addition, it must meet the requirements of health and be suited to the circumstances of time and place and to the needs of the ministry involved. The habits of both men and women religious which do not conform to these norms must be changed." (DNC/WRL)

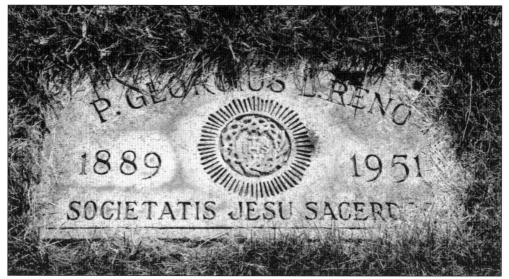

The Society of Jesus (commonly known as the Jesuits) is an international Catholic men's religious order composed of priests, brothers, and scholastics (men studying to be priests). They devote their lives to serving God by serving others. Members of the Society of Jesus work in high schools, universities, retreat houses, and parishes as well as meeting other needs of people here and in other parts of the world. They are buried in section 47, lots 480–493.

In 1877, Casper Borgess, the bishop of Detroit gave his cathedral, SS. Peter and Paul, to the Jesuits provided they open a college in Detroit. Jesuits from St. Louis came to SS. Peter and Paul Church in Detroit and opened the Detroit College. Later named the University of Detroit, it was moved to McNichols Road in 1927. The University of Detroit High School was moved to Seven Mile Road in 1931.

Sr. Margaret Crowley's tombstone is actually a three dimensional cross. It records her birth in 1897 and death September 25, 1944. She was a member of the Sisters of the Sacred Heart. At the time of this photograph, the markers were being laid flat with the surface of the earth and seeded with grass to aid the cemetery in maintaining the grounds. The Sisters of the Sacred Heart are buried in section 47, lots 591–596.

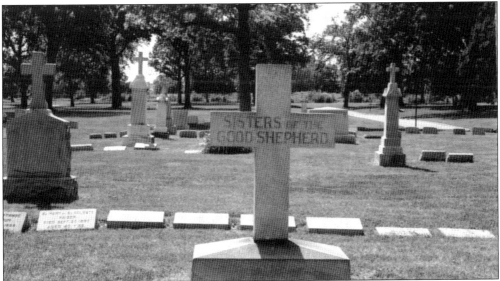

The Sisters of the Good Shepherd arrived in downtown Detroit in 1883 to establish their first home. By the beginning of the 20th century, 33 sisters were caring for more than 200 girls and young women in their facility. In the 1930s, the sisters raised money for new buildings, but lacked property. After the sisters prayed a novena for nine days, a representative of Henry and Clara B. Ford arrived at their door. He announced that the Ford family wished to give the sisters 50 acres of land. They bought the land from the Fords for just $1 and opened Vista Maria in 1942. The sisters are buried in section 47, lots 460 and 461.

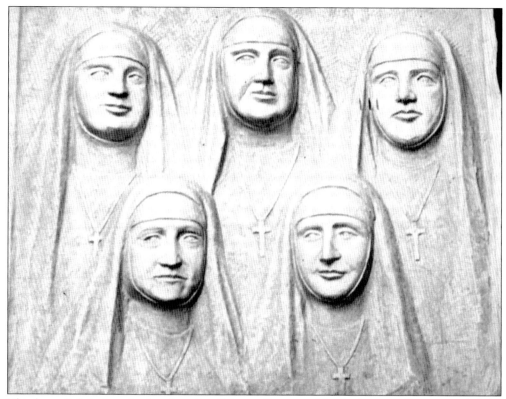

This bas relief depicts the five founding Felician Sisters in North America. Five sisters left for America in response to the request of Fr. Joseph Dabrowski who invited the Felician sisters to teach in his parish school in Polonia, Wisconsin. Nineteen years after the foundation of the community in Warszawa, the pioneer sisters to America arrived in Wisconsin on the eve of the feast of the Presentation of the Blessed Virgin Mary, the beginning of the Felician Sisters' American foundation. They are buried in section 47, lots 522–532. (AFSLM)

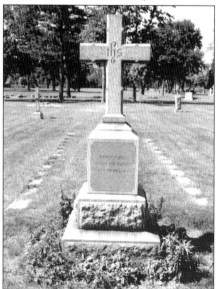

The Felician sisters are officially known as the Congregation of Sisters of Saint Felix of Cantalice (CSSF) and are a religious institution whose members profess public vows of chastity, poverty, and obedience and follow the evangelical way of life in common. Their local chapter was established in 1874 and now includes Madonna University, Ladywood High School, and Angela Hospice.

Sr. Mary Raphael Swozeniowska (1841–1922) became a Felician just one day before departing Poland for North America. She was given the name Raphael since they were departing on the feast day of Saint Raphael, patron saint of travelers. She was one of the group of the first Felician sisters to come to America with four other Felecian sisters in answer to Father Dabrowski's request. (AFSLM)

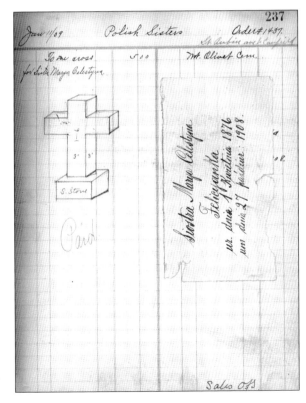

The Felician sisters entrusted their memorials to Otto Schemansky. They had commissioned him to erect the memorial at Mount Elliott Cemetery for Father Dabrowski, so it was natural to ask him to make crosses for the sisters' gravesites as well. Here is the record for the order of a cross for Sr. Mary Celestyna. Born in 1876, she died in 1908. They requested her inscription be in Polish. The motherhouse was located at St. Aubin and Canfield Streets. It would not be until 1936 that it would move to Livonia. (BN)

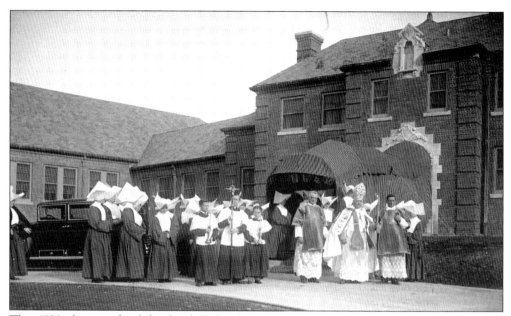

This 1929 photograph of the Sarah Fisher Home captures the Daughters of Charity wearing their white cornette which identified them worldwide. On September 20, 1964, each of the 45,000 sisters worldwide set aside the distinct bonnet for a simple dress. The heavy linen head covering had to be washed and soaked in the heaviest starch and laid flat on a sheet of tin to dry. Once dry they were folded into their distinct shape and held will small pins. They are buried in section 47, lots 567–572. (DNC/WRL)

The Sisters of Charity of St. Vincent de Paul have celebrated 150 years of service to Detroit. Arriving in 1844, they have since established: a hospital in the northwest territory, a hospital to treat infectious diseases, a private psychiatric hospital, a home for unwed mothers, an orphanage, and three schools. Sr. Olympia Bradley died in 1935 and is remembered for over two decades of administering the House of Providence enterprise. She had always referred to Mount Olivet as her "future home." She is buried in section 47, lot 567.

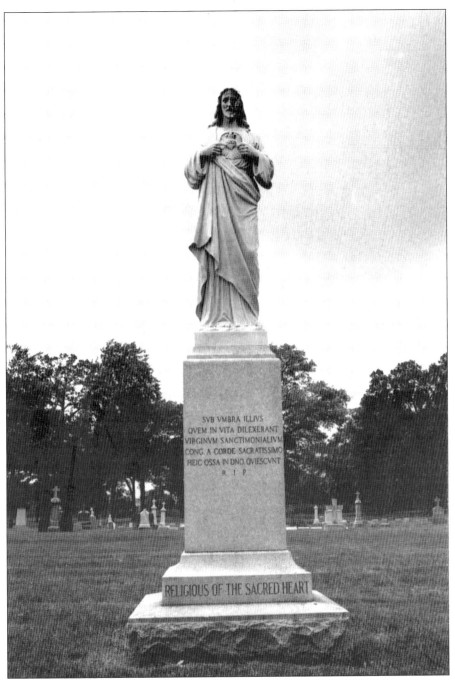

SVB VMBRA ILLIVS
QVEM IN VITA DILEXERANT
VIRGINVM SANCTIMONIALIVM
CONG. A CORDE SACRATISSIMO
HEIC OSSA IN DNO. QVIESCVNT
R I P

RELIGIOUS OF THE SACRED HEART

Invited by the Antoine Beaubien family, five Religious of the Sacred Heart sisters arrived in Detroit in 1851. The nuns opened a school on Jefferson Avenue. From 1851 to 1861, the school occupied three different locations on Jefferson Avenue. The religious order also taught in French, Italian, and English speaking parishes. In 1861, they established a new school located on Lawrence Avenue from 1918 to 1958, and later moved to Bloomfield Hills. A Michigan historical marker indicates the original site of their school in downtown Detroit. They are buried in section 45, lots 582–599.

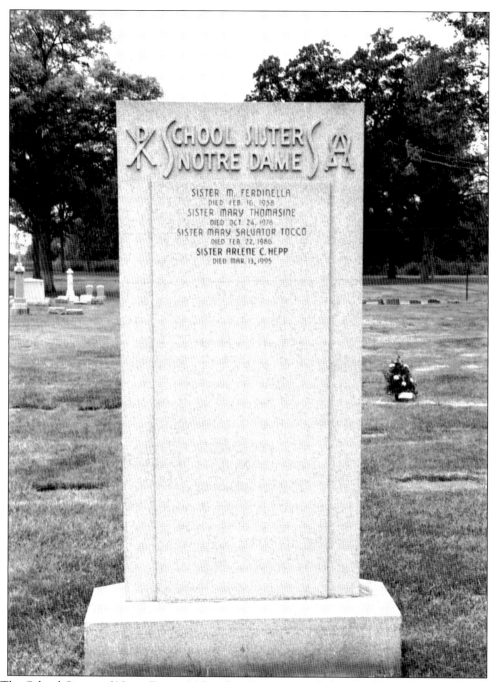

The School Sisters of Notre Dame, Milwaukee Province, includes all of Wisconsin, Michigan, and Indiana. The congregation of the School Sisters of Notre Dame was created to address educational needs of the new immigrants. In 1847, Mother Theresa brought her sisters to the United States to meet the educational needs of the children of German immigrants. In September 1911, the Sisters of Notre Dame opened the San Francesco School in a rented space. In 1923, they moved into a modern building. The school closed in 1952. They are buried in section 47, lots 565 and 566.

For nearly 90 years, the Sisters of Bon Secours have served the east side community, providing "Good Help to Those in Need." It all began in 1909, when five Sisters of Bon Secours arrived in Michigan from Baltimore, embarking on a mission of nursing the sick and indigent in their homes. In 1911, the sisters moved to a new convent on McClellan Street near Gratiot Avenue on the city's east side where they provided home nursing care. They would walk or take streetcars or buses to treat patients with pneumonia, typhoid fever, and all types of contagious diseases. They are buried in section 47, lots 466–469.

ST. CHARLES RECTORY
Detroit, Michigan

September 27, 1945.

Dear Reverend Father:-

My brother, Norbert L. DePuydt, died today. The funeral will be from St. John Berchmans Church, Detroit, Michigan, on Monday, October 1st, at 10:00 A.M.

Kindly remember him in your prayers.

Sincerely yours in Christ,

Ernest C. DePuydt.

The typical black bordered postcard was sent by Fr. Ernest C. DePuydt who was a parish priest at St. Charles in Detroit. Father DePuydt sent the announcement on September 27, 1945. The funeral for his brother, Norbert L. DePuydt (1895–1945), was held at St. John Berchman Church in Detroit and he is buried at Mount Olivet in section 21, lot 511. He was survived by his wife Agnes and children Virginia, Lorraine, and Norbert.

In 1851, Bishop Paul Lefevre of Detroit invited the New York Province of Brothers to take charge of a school at St. Anne Church. Four other schools were opened at St. Mary, St. Peter, Holy Trinity, and Cathedral parishes. All were closed in 1865 as a result of the depression that followed the Civil War. After a brief interval, the brothers were recalled to St. Mary parish. In 1889, the brothers started St. Joseph Commercial College. Then, in July 1944, the brothers purchased the site from the Archdiocese and renamed it St. Joseph High School. In 1922, Bishop Michael Gallagher approved the Brother's new project to build an independent school, De La Salle Collegiate, and classes started in 1926. St. Joseph High School was closed in 1963. In 1982, De La Salle Collegiate moved to Warren, Michigan, and is still in operation. In 1963, the St. Louis Province of the Brothers opened Bishop Gallagher High School in Harper Woods. It was closed in June 2005, though the brothers had departed in 1991. They are buried in section 47, lots 560–564. (JM)

Eight

MILITARY

Edmond Melcher (1900–1918) was born in Michigan and his parents were Otto and Emma. His mother was also from Michigan but his father came from Germany. It is unknown whether Edmond had a military funeral, which is the right of all veterans upon family request. Public Law 106-65 requires that every eligible veteran receive a military funeral honors ceremony, to include folding and presenting the United States burial flag and the playing of taps. The law defines a military funeral honors detail as consisting of two or more uniformed military persons, with at least one being a member of the veteran's parent service of the Armed Forces. The Department of Defense program calls for funeral directors to request military funeral honors on behalf of the veteran's family. Edmond is buried in section 16, lot 136.

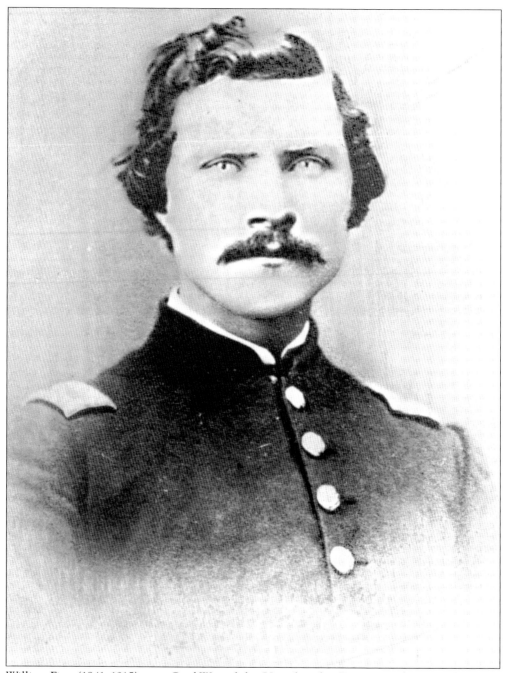

William Finn (1841–1915) was a Civil War solider. He enlisted in Detroit, Michigan, at the age of 20, as a sergeant, mustering-in on January 7, 1862. He was wounded while arresting a Confederate and was commissioned as a 2nd Lieutenant on May 23, 1863 and then as a 1st Lieutenant on July 14, 1864. At the battle of Jonesboro, Georgia, on September 1, 1864, he suffered a gunshot and saber wound to the head, and was discharged due to disability on December 15, 1864. William Finn, who died in 1915, is buried in section 40, lot 155, next to his son William Finn, who died in 1920. (TF)

Nicolas Woods (1844–1930) is interred with his wife Laura Gale (1863–1926). Their lot has 15 graves with only two in use. Intrigued with Nicholas's Civil War service, his grandnephew William (Bill) Oliver compiled the military accounts of the battles and strategies of General Sherman, under whom Nicholas served. He shared this history with his family. On a summer day in 1993, Bill visited the Woods' grave site with his son, Joe, and grandsons, Richard and Daniel. Nicolas is buried in section 28, lot 432.

Nicolas Woods's tombstone chronicles his service during the Civil War. His Illinois record describes him as five feet, six and a half inches tall with black hair and blue eyes. He joined in Dixon, Illinois, and served in Company I of the 13th Illinois Infantry from May 1861 to June 1864. Battles that he was in are immortalized on his tombstone and include the Vicksburg Campaign, Ringgold Gap, and Arkansas Post.

During World War I, Canadian men who wished to serve in the air force joined the Royal Air Force. Aviator Irwin F. Buchanan (Commonwealth War Dead, United Kingdom, Service No. 153685, Unit 42nd Wing, Cadet, Royal Air Force) died July 13, 1918. The son of William H. Buchanan, his mother was Alice and his younger brother was Lester. While born in Michigan, he had Canadian heritage. The family resided at 7241 Sheehan Avenue, Detroit, Michigan. He is interred in section 21, lot 1560-B.

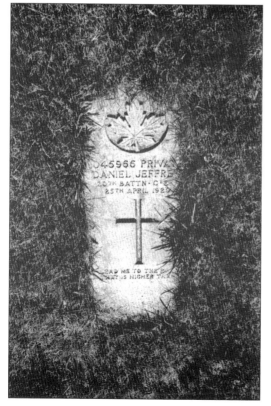

Daniel D. Jeffrey (Canadian Infantry, Central Ontario Regiment, Private No. 1045966) has a tombstone that was issued by the Commonwealth War Graves Commission, an organization which pays tribute to the 1.7 million men and women of the Commonwealth Forces who died in the two world wars. It is a non-profit organization that was founded by Sir Fabian Ware. Private Jeffrey is interred in section 47, lot 129. Not photographed is: Maurice McAleer (Private, Canadian Infantry, Western Ontario Regiment), son of John McAleer, of 729 Maybury Grand, Detroit, Michigan, who died Jan 22, 1919, and is buried in section 47, lot 390.

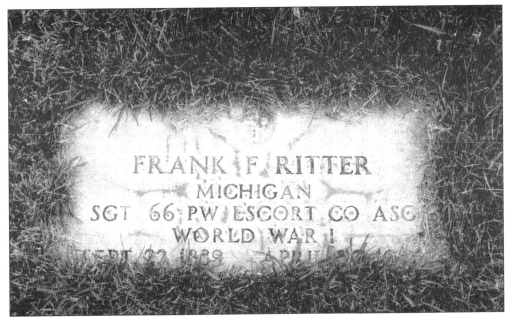

The gravestone of Sgt. Frank Felix Ritter (1888–1957) is pictured here. Son of August J. and Mary Anna (née Koss), Frank served in the U.S. Army from 1907 to 1919. He served in Cuba with the Army of Cuban Pacification from 1907 to 1909, and was a prisoner-of-war escort during World War I, bringing German prisoners to the United States. He is buried in section, F, lot 496.

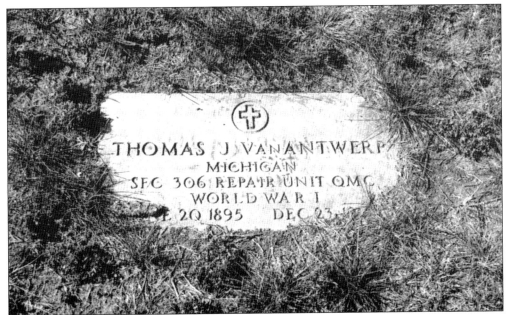

Thomas J. Van Antwerp, son of Eugene, stated in his World War I draft registration that he was the eldest son and cared for his widowed mother Cecilia and seven siblings running the family coal business. He is interred in section 28, lot 731.

HEADQUARTERS 409TH INFANTRY REGIMENT
Office of the Chaplain

Austria
18 May 1945

Mrs. Mary Krul,
2349 Evaline,
Hamtramick, Michigan.

Dear Mrs. Krul:

 Please allow me as a Catholic priest and an Army Chaplain to extend to
you my deep sympathy with you in the loss of your husband, Staff Sergeant
William J. Krul, 36548570, Company A, 409th Infantry.

 On 19 December 1944, in the vicinity of Willer, France, William's Com-
pany was attacking in a north east direction to protect the Battalion's left
flank. The 3d Platoon, led by William, was given the mission of securing a
section of high ground in the Company's front. During the ensuing action,
William was personally leading his platoon and had nearly reached his object-
ive when fire from a concealed bunker and an adjacent machine gun opened on
him. In an effort to take the bunker by marching fire, William, still in
front, was hit by an enemy bullet. He was believed at the time to have been
killed, but due to the lack of positive proof was reported as missing in
action. Conclusive evidence of William's fate was not received until 15 May
1945 and it was then that he was reported as killed in action.

 Perhaps you may find further consolation in the opinion of the Belgian
Cardinal Mercier, hero of another war, that a man who dies for his country
is a martyr, and the crown of martyrdom identifies its wearer as one for whom
the portals of Heaven must be immediately opened.

 Again, allow me to express my warm personal sympathy and assurance that
I shall continue to remember your husband in my prayers and Mass.

Sincerely yours in Christ,

HARRY C. RYNARD
Chaplain, USA

William J. Krul was married to Mary Starzynski on May 10, 1941, in Detroit. He was killed in action during a conflict in World War II near Bollenborn, Germany (between Weiler, France and Rechtenbach, Germany). His son, William Jr., was two years, nine months old when his father was killed. Bill Jr. never knew his father since he was too young to remember him. In 2005, he began researching some of his father's military records. After letters to the military records office, and with help from the Macomb County veteran's group, William J. Krul was finally awarded the military Bronze Star Medal for Valor. He also was awarded the Purple Heart posthumously in 1945. William is interred in section 56, tier 21, grave 626. (WK)

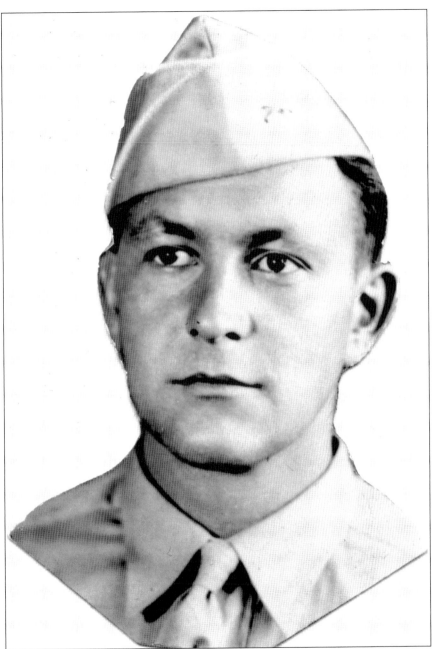

Richard Weaver, an army veteran from Macomb Township and director of Macomb County Department of Veterans' Services, did not hesitate to track down the military awards for the family of Staff Sgt. William Krul Sr., who was killed in action during the Battle of the Bulge on December 19, 1944. Sergent Krul had earned a Bronze Star and a Purple Heart for protecting his platoon against enemy gunfire during the attack, but his family never received the medals. Weaver tracked down Sgt. Krul's military service records after he was contacted by Krul's son, William Krul Jr. of Chesterfield Township. After he reviewed Sgt. Krul's service history, Weaver made a few telephone calls to his military contacts in St. Louis to make sure that Sgt. Krul also received the V device for valor to add to his medal. (WK)

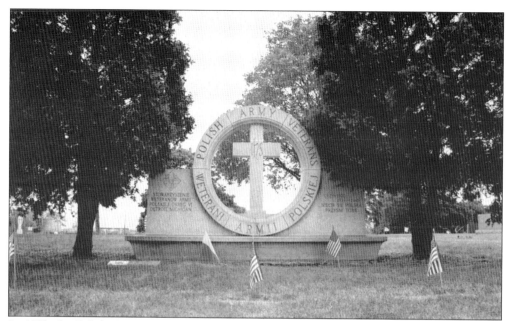

In 1955, the Polish Army Veterans *Weterani Armii Polskiej* purchased lots in section E. Each Memorial Day (*Dzien Pamieci*), the group gathers to honor the World War I and World War II veterans. Inscribed on the circle is Polish Army Veterans—Weterani Armii Polskiej. Inscribed on the cross is IHS in script. The Polish Army Veterans are found in section E, lots 1–6, 48–50, and 114.

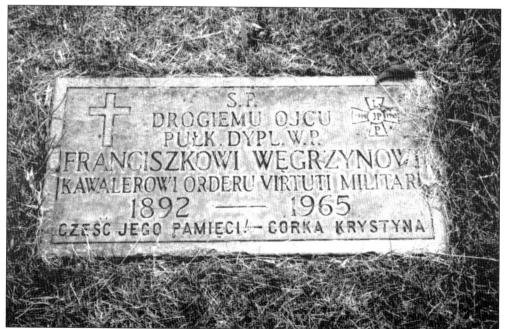

Franciszkowi (Francis) Wegzynowicz (1892–1965) was a Fellow of the Order of Virtuti Militari (highest Polish military honor, equivalent to the U.S. Medal of Honor). His *corka*, (daughter) had "honor is memory" inscribed on the headstone (translation courtesy of Arthur Wagner). He is buried in section E, lot 4.

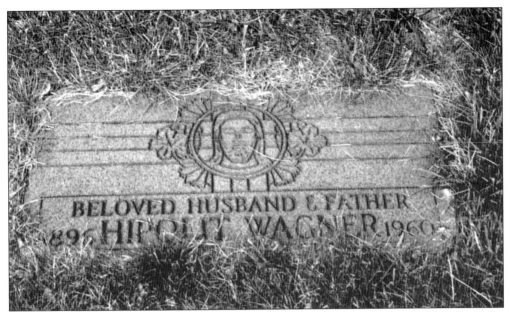

Before he died, Hipolit Wagner reminded his family that he planned for a military funeral since he had paid his dues to the Polish Legion of American Veterans (PLAV). For his funeral, the PLAV dispatched a group of veterans in uniform. At the graveside service, the veterans saluted, gave a farewell speech, and fired three volleys. The final part of the ceremony was most moving. They sang the traditional Polish soldier's hymn containing the words: "How glorious is war. . . . Sleep, colleague, in the dark tomb, May Poland appear in your dreams." Wagner is buried in section 52, lot 204.

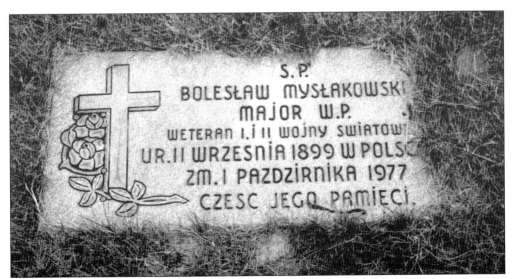

Boleslaw Myslakowski (1899–1977) was a veteran of both World War I and World War II. "S.P." written in Polish means "in sacred memory" and *Czesc Jego Pamieci* means "honor his memory." Myslakowski is interred in section E, lot 6.

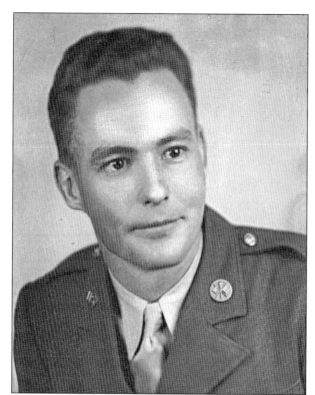

Clarence MacDonald Anderson's granddaughter Camille Sylvain Thompson has researched her grandfather's World War II service. She wanted to find out if he had been part of D-Day. Tec 5 Anderson enlisted at Camp Blanding, Florida, in 1942 as a recording engineer/radio or electrician. He is interred in section 49, lot 283. (CST)

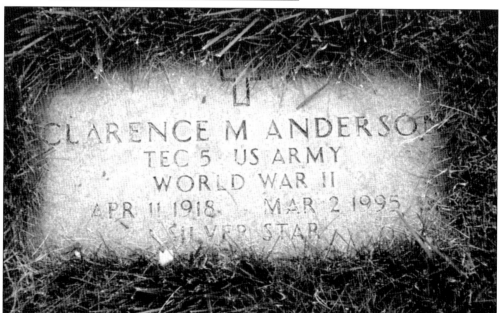

Anderson had always told his family that he was in Normandy on D-Day and his grave marker lists a Silver Star decoration. He had Nazi daggers and other weapons, decorations, and papers from the battlefield. He was in the 4th Signal Company unit, and it is listed that Normandy was one of his tours along with Ardennes, in the north of France. His company was part of the 4th Infantry Division. Camille Sylvain continues her search for more documentation.

Nine

IN THE NEWS

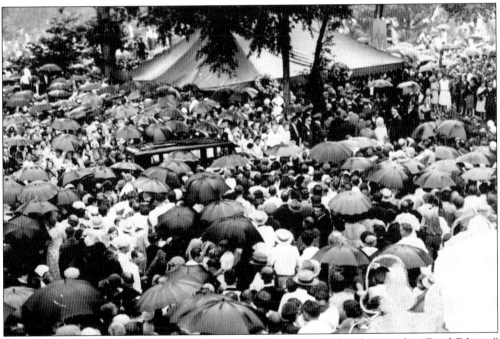

"Part of the Throng that Assembled at Mount Olivet" was the heading in the "Final Edition" of *The Detroit News*'s July 27, 1930, coverage of Gerald "Jerry" Buckley's funeral. The coverage continued: "At the end of services (at St. Gregory's Church) the funeral moved to Mount Olivet Cemetery, Six Mile Road and Van Dyke Avenue. It moved through a mass of people that extended all the way to the cemetery gates. Thousands upon thousands lined the streets and stood as the hearse went by with bowed and bared heads. The cemetery was packed by a throng that was estimated by the Inspector John W. Bates of the Gratiot Precinct to be 30,000 and a crowd almost half as large pressed against the walls and gates of the cemetery. The rain began to fall as the funeral neared the gates. It needed only the gray skies and the depression of the rain to bring to the surface the grief of thousands and the sound of open sobbing rose even above the roar of the motorcycles of the police and the duller hum of the parade cars." (DNC/WRL)

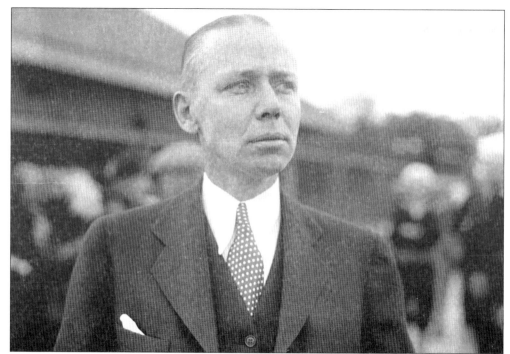

Gerald Buckley (died 1930) was gunned down in the lobby of the LaSalle Hotel after successfully leading a radio recall campaign against the mayor of Detroit, Charles Bowles. He was eulogized by Father Charles E. Coughlin and Judge Moll. *The Detroit News* published: "A priest and a judge spoke into his microphone at Station WMBC, voicing eulogy and sorrow for him. Fr. Coughlin lauded Buckley's fight for the city's needy, for old age pensioners and for civic honesty." (DNC/WRL)

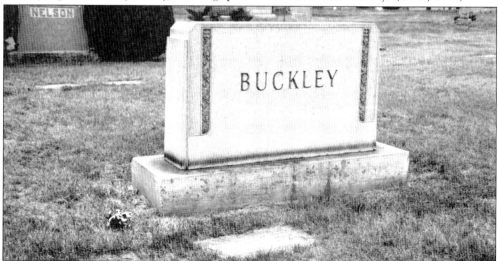

The mourners were lead by Buckley's wife Jeanette, daughter Rose Mary, and father Jeremiah C. Buckley. An anonymous writer to *The Detroit News* asked that "any poor of the city who feels as if they would like to do a good turn for their dearest friend, who slaved night and day for their welfare, may do so now." The writer asked for contributions from one penny on up to buy a blanket of flowers for the casket. The radio station WMBC collected funds from the contributors. Gerald is interred in section 32, lot 859.

John Lesinski (1885–1950), a Democrat and representative from Michigan, was born in Erie, Pennsylvania, on January 3, 1885. He attended St. Albertus School, SS. Cyril and Methodius Seminary, and Detroit Business University. He was involved in building and real estate and established lumber and supply companies in the Hamtramck and Dearborn areas of Detroit. He was president of the Polish Citizens' Committee of Detroit from 1919 to 1932. He is buried in section 40, lot 136.

Louis C. Rabaut (1886–1961) studied law at the University of Detroit. He was married to Stella M. Petz of Detroit. Louis, a deeply religious man, was the author of the 1945 Amendment inserting the words "under God" in the Pledge of Allegiance to the U.S. flag and of the legislation placing a cancellation mark on mail using the words "pray for peace." Louis is interred in section 35, lot 60.

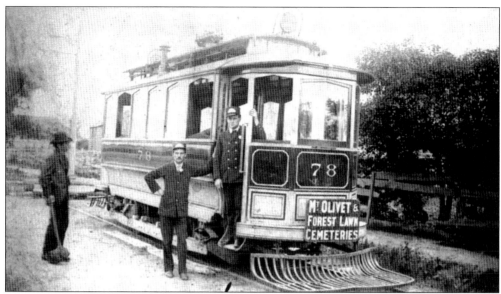

The Mount Olivet and Forest Lawn Cemetery Trolley is pictured. A story reported by *The Detroit News* on December 14, 1908 stated: "While the funeral cortège of James Allen Hogan, the victim of a street car accident, was on the way to Mount Olivet Cemetery at 10:30 AM this morning, a Michigan Avenue Line car crashed into the hearse at Gratiot Avenue and Hastings Street. The carriages were just turning into Gratiot Avenue from Hastings St. and the vehicles containing the pall bearers and priests had cleared the track when the hearse was struck. Plate glass was shattered and the casket thrown to the opposite side escaped injury." (MECA)

P. BLAKE. W. F. BLAKE.

P. BLAKE & SON,

Funeral Furnishers

The story continues: "Many women fainted and the priest, assisted by undertaker Blake & Son, who had charge of the funeral were kept busy reviving the horror-stricken mourners. Street car traffic was tied up for some time and many angry remarks were directed at the car. The hearse was the property of Daniel Lyons, liveryman, 527 Gratiot Avenue and was valued at $3,000. The procession was again halted at the livery but all other Lyons vehicles for conveying the dead were engaged and he was obliged to send the smashed hearse on its journey to the cemetery." (MECA)

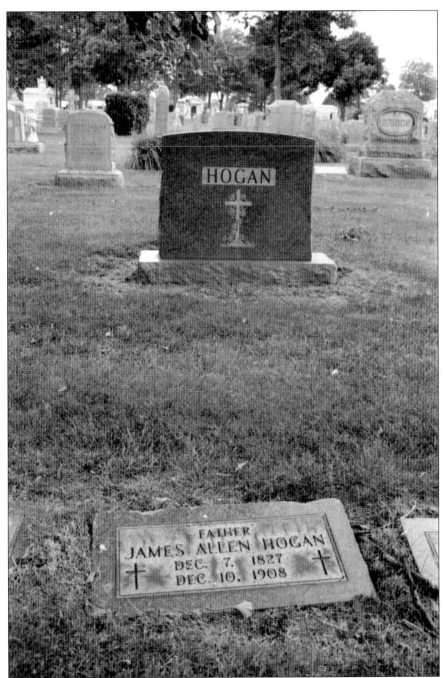

The Detroit News obituary for James Allen Hogan read: "A resident of Detroit . . . and a veteran of the Civil War, in which he rendered distinguished service to the Federal Corps as an engineer, passed away quietly in his home, 9 Beech St., Thursday morning. His talents inclined him to civil engineering and he became one of the party sent by the United States to make an official survey of the Great Lakes. Survived by a widow and five children, his funeral was held at St. Aloysius." His death and funeral were covered in *The Detroit News* December 11, 1908, and in the *Detroit News Tribune*, December 13, 1908. Hogan is buried in section 27, lot 83.

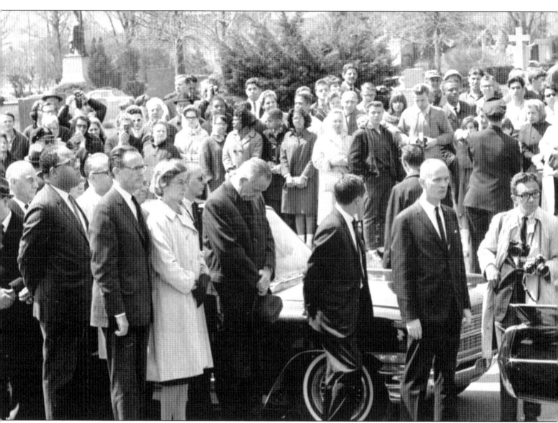

An article in *The Detroit News* of May 5, 1966, stated: "President Johnson flew to Detroit aboard Air Force One accompanied by Senators Eugene McCarthy and Daniel K. Inouye. Governor George Romney and Senator Philip Hart greeted the Washington delegation. Johnson traveled in the presidential hardtop limo from Metro Airport with Air Force helicopters hovering over the freeway. They attended services at Holy Name of Jesus Church where Fr. George thanked the President, 'We are personally grateful that you came to share our sorrow.' Johnson insisted on going to Mount Olivet for the graveside service. He walked with several hundred other mourners to the yellow tent at the graveside. He talked with the McNamara family for three or four minutes. The tall President bent over tiny Mrs. McNamara, his huge hands covering hers. He talked with others of the family and shook hands with all, including the children." (DNC/WRL)

Senator Patrick V. McNamara (1894–1966) was born in North Weymouth, Massachusetts, on October 4, 1894. He attended the public schools in Massachusetts, moved to Detroit in 1921, and became active in union and civic affairs. He served on the Detroit City Council from 1946 to 1947, and the Detroit Board of Education from 1949 to 1955. Elected as a Democrat to the United States Senate in 1954, and reelected in 1960, he served until his death in Bethesda, Maryland, on April 30, 1966. (DNC/WRL)

Senator McNamara is buried with his first wife, Kathleen, and his second wife, Mary. From his eulogy, published in the May 5, 1966, edition of *The Detroit News*: "He must have been a remarkable man, a man of strong character and tireless industry a self made man who worked with his hands and never forgot his humble beginnings, and who, by his own effort, rose to the dignity of the senatorial office. . . . The McNamara family included the senator's widow, Mary, son, Patrick, and daughter, Mary Jane Ballard." He is buried in section 10, lot 376.

Tom Tyler (1902–1954), also known as Vincent Markowski, was a popular American star of silent and early sound Westerns and serials. Born in Pennsylvania and raised in Michigan, he became an action star playing Captain Marvel and the Phantom. When the talkies came in, he worked to lose his accent. He was a weight lifter, but his strength was drained away by the rare disease scleroderma. He was crippled with rheumatoid arthritis and died at his sister's home in Hamtramck in 1954. He is buried in section 15, lot 51.

Tyler's career stretched from the 1920s to the 1950s and he appeared in many films, most of them westerns, such as John Ford's "Stagecoach" and "She Wore a Yellow Ribbon." In addition to playing the Phantom and Captain Marvel, Tyler's career was spent making B-movie westerns. In 1940, he was the mummy in "The Mummy's Hand."

Ten

PRIVATE MAUSOLEUMS

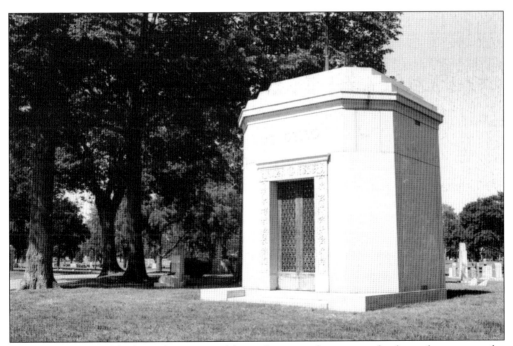

Aaron Mendelson (died 1933) was a wealthy architect and investor who loaned money to the Fisher brothers so they could buy out their uncle Albert Fisher. Aaron was married to Jeannie Grogan (also known as Mary Jane). Aaron's parents were from Germany and Jeannie's from Ireland. Five family members are entombed here: Aaron, his wife Jeannie (1867–1921), son Herbert A. (died 1897), Herbert's wife Marie Mendelson, and Bernard E. Kuhn. They are entombed in their private mausoleum on section 39, lot 2.

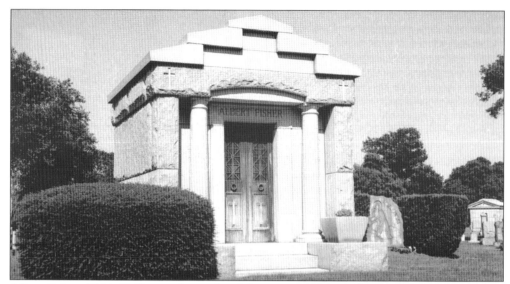

Albert Fisher (1864–1942) was the uncle of the seven Fisher brothers who had such a strong impact on the Detroit auto industry. Entombed in this grand mausoleum are: Albert; his wife Mary (1866–1923); children Carl, Florence, and Mary; and married children Alberta and Robert Henley, Raymond A. and Elsa, Edwin, Helen and John Bernard. Their mausoleum is in section 26, lots 99–102.

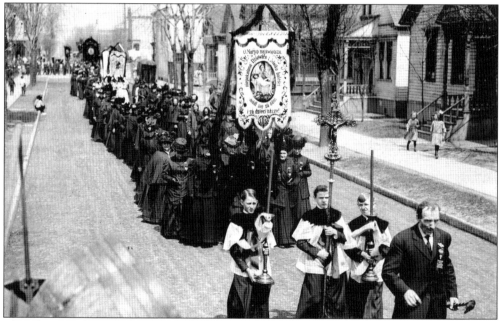

This photograph is believed to be the funeral cortege of Rev. Francis A. Mueller on April 23, 1913. *The Detroit News* reported: "At 10:30 the procession of acolytes, monks, priests and laymen and women, representatives of various sodalities of the church, moved from the rectory to escort the body. Shortly after 11 o'clock the deep tolling of the bells in the steeple announced the approach and the hush of deep prayer came over the entire assembly. Led by a cross bearer and candle bearers the procession moved slowly." Reverend Mueller's mausoleum is in section 40, lot 31. (DNC/WRL)

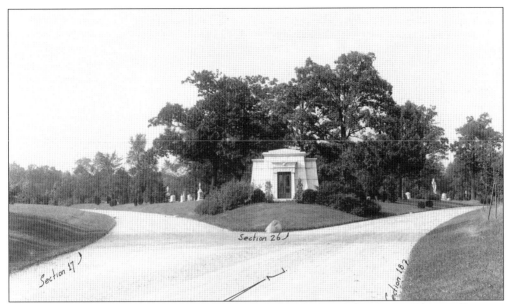

This is the Joseph J. Noeker Mausoleum. He was the owner of the Mount Clemens Brewing Company. Built in 1907, Joseph Sr. and Joseph Jr. were moved from Mount Elliott Cemetery. Also entombed in the Egyptian style mausoleum, complete with Egyptian god Horus' winged solar disk over the doorway, are Christine J., Joseph Jr. and Ivy, and daughters Elsie Noeker (died 1959) and Mary Gabrielle Noeker von Boeselager (died 1948). The mausoleum is in section 26, lot 1. (MECA)

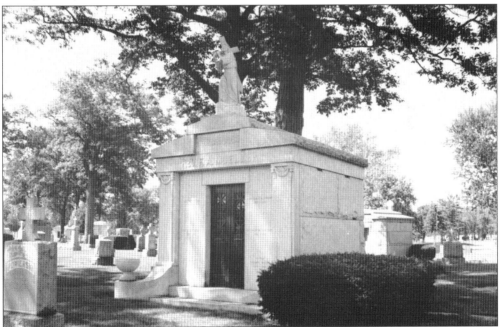

The Mueller Mausoleum was constructed by the Marsh and Sassi Monument Company. Entombed with Rev. Mueller and his mother Catherine Mueller were Rev. Joseph Wilemski, Rev. Francis Doppke, Rev. William Maruszczyk, and Rev. Roman Klafkowski. Wilemski and Klafkowski were assistants to Father Mueller. The mausoleum is in section 40, lot 31.

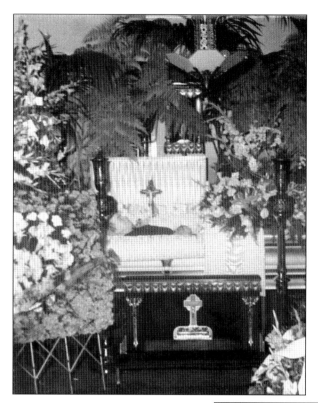

This is a postmortem photograph of John DiNatale (1877–1966). John was thoughtful in his design for his family mausoleum. He put in a small marble altar. On it rests his prayer book, two candle sticks in the shape of angels, a votive light and a dried flower. Framed photographs of John and Margareta rest against the wall. Mausoleums at Mount Olivet are locked and can only be accessed by listed family members. The DiNatale mausoleum is in section 36, lots 101–102. (LDD)

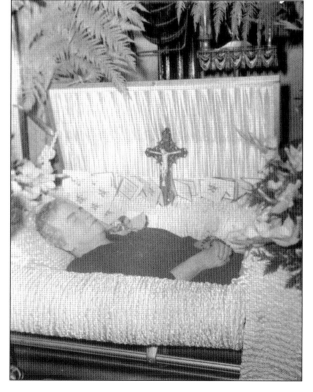

Margareta Borrelli DiNatale (1879–1942) was born in Guardiagrele, Chieti, Abruzzo, Italy. This postmortem photograph was placed in the mausoleum by her husband John with a small inscription written on the back of a funeral memorial card. It was not unusual for immigrants to create postmortem photographs. They would hire a photographer to make multiple copies to send back to families still in Europe. (LDD)

Pictured here is the funeral card for Margareta Borrelli DiNatale. Her funeral arrangements were made by the Frank J. Calcaterra Funeral Home. The John DiNatale (1877–1966) mausoleum was purchased in 1942 for the burial of John's wife Margareta Borrelli (1879–1942). John was also known as Maestro DiNatale in the Italian community. John began his musical study in Palombaro, Chieti, and Abruzzo, Italy. His love of music is symbolized by the musical instruments set into the corners of the doorway of the mausoleum. Entombed in the mausoleum in section 36, lots 101–102, are John and his wife. Burials in front of the mausoleum include John and Margaret's children and their spouses: Albert (1912–1968) and Virginia (née Przytulski) (1913–1968), Vincent (died 1997) and wife Stella (died 2002), daughters Grace Cheatle (1907–1982), and Amelia and husband Walter Wozniak. John shared a Ford Motor Company tradition with his sons. In 1963, the combined company service of John and sons Vincent, Raymond, Joseph, and Albert, totaled 161 years. (LDD)

Blessed are the dead, who die in the Lord, for their works follow them.

My Jesus, have mercy on the soul of

Margherita Di Natale

BORN FEBRUARY 7, 1879
DIED MARCH 28, 1942

PRAYER

O gentlest Heart of Jesus, ever present in the Blessed Sacrament, ever consumed with burning love for the poor captive souls in Purgatory, have mercy on the soul of Thy departed servant. Be not severe in Thy Judgment, but let some drops of Thy Precious Blood fall upon the devouring flames, and do Thou, O Merciful Saviour, send Thy angels to conduct Thy departed servant to a place of refreshment, light and peace. Amen.

Eternal rest grant unto her, O Lord! And let perpetual light shine upon her.

Sacred Heart of Jesus, have mercy on her.

Immaculate Heart of Mary, pray for her.

St. Joseph, friend of the Sacred Heart, pray for her.

(100 days for each aspiration)

FRANK CALCATERRA FUNERAL HOME

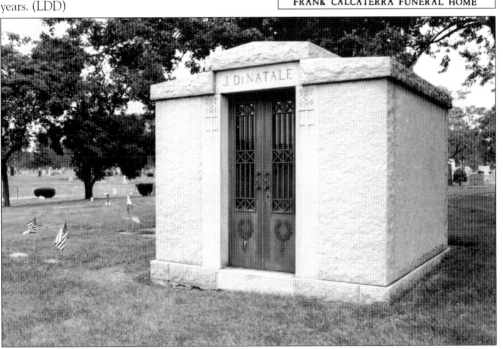

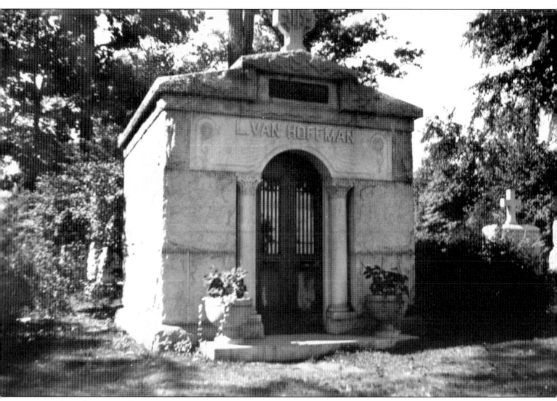

This photograph of the Louis E. Van Hoffman (1870–1916) mausoleum was taken by Schemansky and Son. It shows the mausoleum shortly after it was erected. Over the doorway on a small plate is the surname Kramer. Van Hoffman was of German and Belgian ancestry and was the owner of a grocery. He and his wife Arlene (1896–1923) lived on Mount Elliott Avenue. Arlene was of English Canadian ancestry. Louis came from a big family. He had one brother and eight sisters. His parents were William and Anna Van Hoffman. The mausoleum is on section 40, lots 39–40. (BN)

Arlene Van Hoffman Kramer, residing on Seyburn Avenue, placed her order for the mausoleum to be built by Otto Schemansky and Sons. The ledgers preserve the initial sketch. A total of $1,529 worth of granite was ordered from the Woodbury Granite Company in Vermont and slate was ordered from the Albion Bangor Company. The window for the mausoleum cost $30. The bronze doors are not on the order form. (BN)

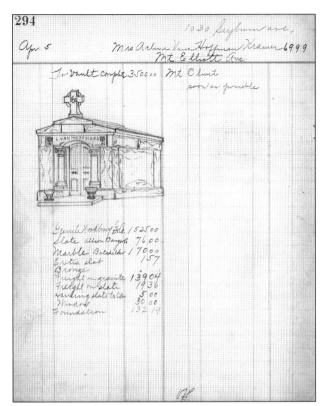

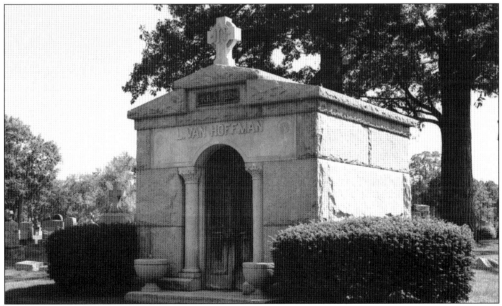

The Van Hoffman mausoleum is as stately as the sketch. It has rusticated stone, the columns have Corinthian capitals, and the formal entry is graced with urns on either side. The cross topping the pediment displays the letters IHS which are a monogram of the name of Jesus Christ. In Christian inscriptions, the nomina sacra, or names of Jesus Christ, were shortened by contraction, thus IC and XC or IHS and XPS for Iesous Christos.

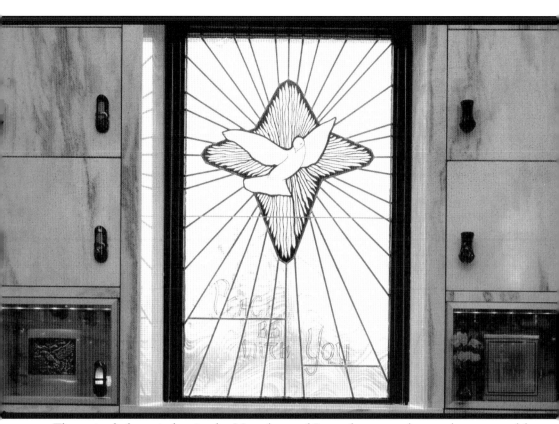

The stained glass window in the Mausoleum of Peace features a dove and a cross and later became the inspiration for the logo of the Mount Elliott Cemetery Association. The window was designed by the late Cheryl Neuberger of Artisan Designs. (MECA)

BIBLIOGRAPHY

"Civil War Veteran Dead." *The Detroit News.* Tribune December 13, 1908.

"Detroit Given a Glimpse of President as Mourner." *The Detroit News.* May 5, 1966.

The Detroit Society for Genealogical Research Magazine, The Detroit Society for Genealogical Research, Inc., Detroit, MI. Spring 2006: 137–138.

"DiNatale Family Totals 161 Years of Company Service." *Tractor Division News.* June 21, 1963.

Eaglet, The Polish Genealogical Society of Michigan, Detroit, Michigan, Vol. 23, Number 1, Spring 2003: 25–28.

"Exiles from Land of War are Re-united." *The Detroit News.* August 8, 1915.

Family Trails, Michigan Department of Education, Volume 5, Number 4, Winter 1977–1978.

Farmer, Silas. *The History of Detroit and Michigan; or, The metropolis illustrated; a chronological cyclopaedia of the past and present including a full record of territorial days in Michigan, and the annuals of Wayne County.* Detroit, MI, 1884.

"Father and Four Sons Build Up 109 Years of Ford Service." *Rouge News.* January 20, 1950.

"Hearse Jammed by Michigan Car." *The Detroit News.* December 14, 1908.

"James A. Hogan is Dead." *The Detroit News.* December 11, 1908.

Luedtke, Eleanor. Caritas Christi, 1844–1994: "The Daughters of Charity of St. Vincent de Paul: 150 years of service to Detroit; Southfield, MI; Providence Hospital and Medical Centers and the St. Vincent and Sarah Fisher Center." 1994.

"Memorial Day." Dzien Pamieci. June 6, 2002.

Sabbe, Philemon D. and Leon Buyce. Belgians in America. Lannoo: Publishing office Lannoo, 1960.

"Slain Family's Rites are Held." *The Detroit News*, Home Edition. July 6, 1929.

White, Rex G. "Buckley Rites Draw 100,000." *The Detroit News*, Final Edition. July 27, 1930.

Wendland, Michael F. "Tony Jack Guards Door at Zerilli Service." *The Detroit News.* November 3, 1977.

Visamara, Rev. John C. "Coming Of the Italians to Detroit." 1918.

Verthe, Arthur. *150 Years of Flemmings in Detroit.* Llano: Publishing Office Llano, 1983.

Ziolkowski, Mary J. *The Felician Sisters of Livonia, Michigan: First Province in America.* Detroit, MI: Harlo Press, 1984.